A–Z

OF

COLWYN BAY

PLACES - PEOPLE - HISTORY

Graham Roberts

AMBERLEY

For four born-and-bred Colwyn Bay children: Gavin, Alice, Lucy and Rachel

First published 2018

Amberley Publishing
The Hill, Stroud, Gloucestershire, GL5 4EP
www.amberley-books.com

Copyright © Graham Roberts, 2018

The right of Graham Roberts to be identified
as the Author of this work has been asserted in
accordance with the Copyrights, Designs and
Patents Act 1988.

ISBN 978 1 4456 8161 0 (print)
ISBN 978 1 4456 8162 7 (ebook)

British Library Cataloguing in Publication Data.
A catalogue record for this book is available
from the British Library.

Origination by Amberley Publishing.
Printed in Great Britain.

Contents

Introduction

No encyclopaedia of any town can be comprehensive. I have tried to include what I hope will be of interest to anyone who wishes to learn a little of the history and make-up of this delightful town perched on the North Wales coast.

The Romans visited Colwyn Bay and the area is rich in associations with folk who travelled from one of Edward I's castles to another. Monks lived in uncomfortable, cold dwellings at Rhos Point and built a weir to catch fish. Queen Victoria's influence is everywhere from the naming of the pier to pubs and roads. Mr Cayley, one of the first men to imagine that man could fly in an aeroplane, lived in Rhos-on-Sea and left his name attached to a local pub. In Rhos-on-Sea is the only dedicated and custom-built marionette theatre in Great Britain. Terry Jones from *Monty Python's Flying Circus* lived here during the Second World War, during which the whole of the Ministry of Food decamped from London to Colwyn Bay. It is 847 years since Prince Madoc sailed from Llandrillo-yn-Rhos to discover America and ninety-seven years since David Lloyd George laid the foundation stone of Westfield (a Penrhos School boarding house) on Llannerch Road East, which has since been demolished and replaced by a housing estate. The town, once upon a time, had six cinemas but now it has none.

In the 1790s the first tourist, Thomas Pennant, arrived in the area and in 1811 Thomas Telford visited the town and compiled a report on our 'main' road, now Conwy/Abergele Road but then known as London Road because that is where it led to. In 1865 Lady Erskine, the local landowner, sold her estate and the town slowly began to evolve into the diverse, busy town that we know today.

Only eighty years ago more or less everyone walked everywhere. Today the town is clogged with cars, lorries and motorbikes, parking is a problem and wardens roam the streets fining people for leaving their cars parked for too long, dropping litter and cigarette stubs and for not cleaning up after their dogs have fouled the pavements. Fifty years ago all the shops closed on Wednesday afternoons and everything, except the churches, closed all day on a Sunday. The town has gone from a contented, leisurely world to a hurrying, harassed community. Much like any other town in fact.

In the following pages there are numerous references to the town and its residents as it stands today and the historical basis on which it was founded. It is, of course, a personal selection from a myriad of possibilities.

Abbeyfield

There were five Abbeyfield homes in Colwyn Bay. One on Kenelm Road and one on Llanelian Road have been closed, leaving Nos 10 and 12 Alexandra Road, No. 9 Whitehall Road and No. 71 Rhos Road. The Alexandra home has been converted from two large semi-detached houses, Gwenallt and Cartrefle. In the 1950s the Colwyn Bay borough medical officer of health, Dr William McKendrick, lived next door. The Whitehall home is a former seaside villa built in the 1930s and the home on Rhos Road is a large house converted from two semi-detached houses, Cranley and St Heliers,

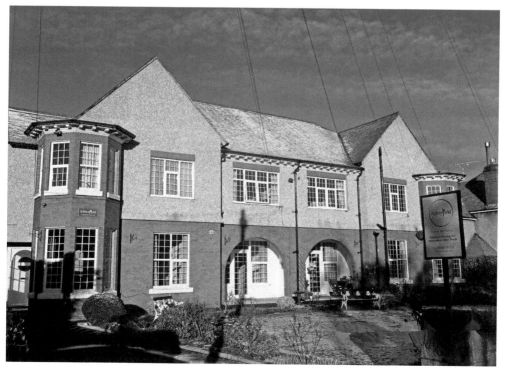

Abbeyfield House on Grosvenor Road.

where in the 1940s Miss Chubb once lived. They are excellent homes providing independent sheltered housing for people over the age of fifty-five. It is a non-profit organisation where the residents live a comfortable, safe life, with their dignity intact. The Abbeyfield idea was the brainchild of former army officer Richard Carr-Gomm OBE. He was helped in his endeavour by Sir Nicholas Winton MBE, who saved 669 Jewish children from the Holocaust just before the Second World War began. A blue plaque in Gomm Road in Bermondsey commemorates Mr Carr-Gomm and the founding of the Abbeyfield Society.

Alverton

During the Second World War, this building, a hotel on Marine Road opposite the Colwyn Bay Hotel, was home to dozens of Ministry of Food civil servants. Alverton is a hamlet of around two dozen houses surrounded by farming land in Cheshire. After the war, in an effort to survive in a changed world, the owners, George and Pat Owen, amalgamated their hotel with the one next door, the St Enoch's. For a while their business was called after both hotels, St Enoch's & Alverton, but they eventually called the whole venture the St Enoch's Hotel. The Owens retired in 1989 and went to live in a house on Yerburgh Avenue (No. 19), which they inevitably called Alverton. Of the pair of them Mrs Owen was the boss, and it was she who decided on the name after declaring, 'Well, we can't call it St Enoch's.'

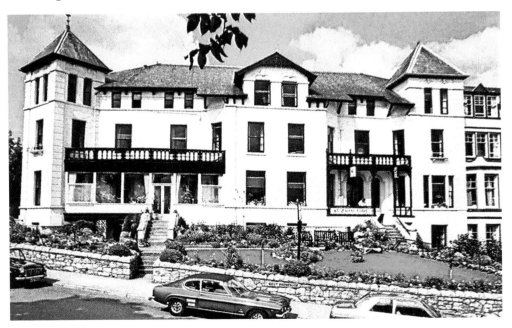

St Enochs, *c.* 1979.

A55

On 28 June 1985 the new A55 dual carriageway expressway was opened by Wyn Roberts MP, the parliamentary under Secretary of State at the Welsh Office. Before this road was built the traffic in Colwyn Bay had become horrendous. The proposed route of the road was not only projected to split the town in two and make access from the town down to the promenade difficult, but it also split the opinion of the community. In 1966 the Welsh Office set up a local study team to consider the traffic problems in Colwyn Bay. The Colcon Report was compiled by an independent committee, at great expense, to decide whether the road should be built through the town or go over the agricultural land at the back of the town, bypassing Rhyd-y-Foel and emerging at Glan Conwy Corner. A public inquiry into which route should be used commenced in May 1975 and lasted for 102 days. Chaos ensued while the road, the demolition of houses, the building of bridges and erection of concrete retaining walls was completed. A totally new underpass was built beneath the railway station forecourt. The old Tan-y-Bryn Road bridge and the West End Road bridge and the wrought-iron bridge across the railway line to the Penrhos School site were dismantled. The railway line had to be shifted sideways and a piece of Bryn Euryn had to be sliced away. In their place were built eleven new bridges and 1.5 km of retaining walls. Beyond Mochdre

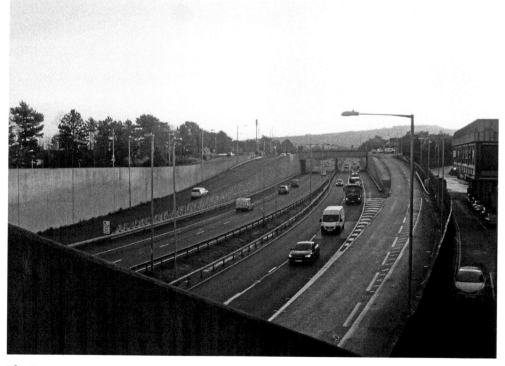

The A55.

the ground consists of soft alluvium up to 12 m thick, which necessitated sinking a piled raft overlain with unreinforced PFA/OPC 800-mm-thick concrete on 16,000 concrete shell piles. The whole exercise was a huge engineering feat and has been a blessing to the future of the town.

Allanson Road

This road is named after George Allanson Cayley. In 'The Abstract of the Title of the Trustees of a settlement of 12th July 1882 to freehold hereditaments in the Parish of Llandrillo-yn-Rhos in the County of Denbigh', drawn up by Nunn & Co. (solicitors in Colwyn Bay), mention is made of George Allanson Cayley and Sir George Everard Arthur Cayley, both of Llannerch Park, and Digby Cayley of the Green, Brompton. By 1904 Sir George Everard Arthur Cayley was deemed to be bankrupt and was supposed to turn up at court in London, which for whatever reason he failed to do. The family legacy in Colwyn Bay is to have the Cayley pub in Rhos-on-Sea, the promenade in Rhos-on-Sea, Everard Road, Digby Road, Llannerch Road West and East, and Brompton Avenue and Brompton Park named after them.

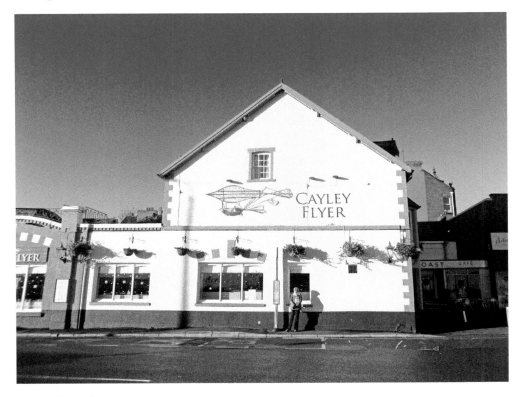

The Cayley pub.

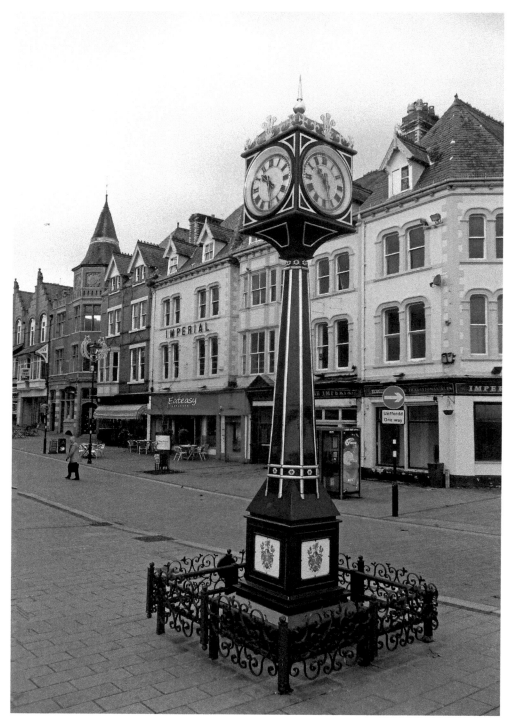

Andrew Fraser Clock.

A

Andrew Fraser Memorial Clock

Mr and Mrs Stan Fraser donated the clock to the town in memory of their son, Andrew P. Fraser BSc, FCA, who was born in 1950 in Colwyn Bay and died in February 1984 in Brussels. Mr Fraser was a well-respected local businessman and Andrew was his only child. During the Second World War Stan was stationed on Malta. In 1975 he saved the guns of Hagar Qim, which had been used to defend the island during the war, by funding their restoration and donated them to the island, where they stand proudly to this day.

Arnold House

This is a large house in Llanddulas (once known as Llanddulas Hall) on the side of the hill, up Pentrgwyddel Road. What is left today is but a remnant of the original hall. In 1925 it was plain and gabled and towered over the quarrying village. Its claim to fame is that in January 1925 Evelyn Waugh started his first job as a school teacher in the building, which was then called Arnold House School. The place appears, thinly disguised, as Llanabba Castle in his 1928 novel *Decline and Fall*. It was a private school and Waugh was twenty-one years old at the time. The headmaster, Mr C. P. Banks, whom Waugh described as 'a tall old man with stupid eyes' and 'amiable and disorganised', had offered him a £160 a year post teaching History, Latin and Greek. Waugh recorded in his diary: 'Apparently the school is so far away from any sort of place of entertainment that it is quite impossible to spend any money at all.' The school closed in 1943 and became a Jewish convalescent home before the first of several incarnations as a holiday camp, where chalets were erected in the grounds in the 1950s. It has now been converted into flats.

Berry's Garage

While Hollingdrakes Garage and Chester Engineering Garage on Princes Drive have disappeared, Rhos County Garage and Penrhyn Garage have long gone from Rhos-on-Sea, and Meredith & Kirkham Garage has vanished from Old Colwyn, Berry's Garage keeps going, offering a knowledgeable, expert service. In 1914 the buildings were erected when the business was run by Edmund Berry. David Berry, the present proprietor, is the third generation to work at the garage. The garage is tucked away in Rhos-on-Sea, surrounded by Everard Road and Whitehall Road – a narrow lane leads to the premises from both roads. The first building on the site had been a coaching house, a sort of garage for horse-drawn carriages. The rest of the land was used as allotments and it was on this land that the garage was built. Edmund's brother Frank ran a very successful decorating business from the same premises. Indeed, he had to write to a Mr Jones on 29 May 1919 regarding the decorating of the Isolation Hospital on Dinerth Road: 'We regret that we are unable to undertake above work owing to having more work on hand than we can manage. We thank you for the invitation to tender.' In the 1960s, Miss Berry (no relation), a hospital matron from Sheffield, came

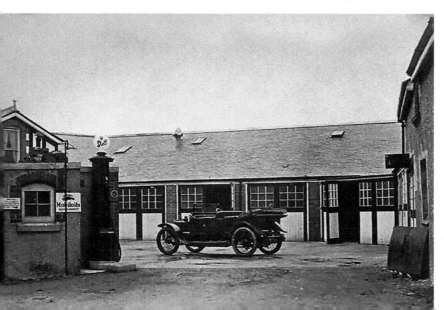

Berry's Garage,
c. 1920.

into the garage unaware that Hughie, a mechanic, was down in the pit beneath a car. He was a garrulous individual with a ripe uncouth turn of phrase. He yelled out that he needed 'a f*****g quarter spanner' and put out his hand on the ground to receive the instrument, at which point, not realising that the awful language was coming from beneath the car, Miss Berry stood on Hughie's hand. This act naturally brought forth from the mechanic a stream of invective of which an army squaddie would have been proud. It was ultimately unclear which of them was the more embarrassed.

Bevan Avenue

In 1937 there was only one house on Bevan Avenue: Overton (now No. 7). Overton was named after a secluded hamlet in South Gower near Port Eynon. The other half of the dwelling is called Mewslade (now No. 2 Gower Road). Mewslade is possibly one of the most beautiful bays on the Gower Peninsular. In Overton lived George Bevan and in Mewslade lived his son, George Jr. The Bevans owned an ironmongery, plumbing and electrical business at No. 36 Princes Drive, Colwyn Bay. The family hailed from the Gower Peninsula, hence the naming of the houses and the road adjacent to Bevan Avenue that were named after the family. On 13 April 1804 it was noted in the local church records: 'Lieutenant Sawyer of the Sea Forcibles was patrolling Oxwich sands with Mr Francis Bevan, the local customs officer, when they noticed a cutter come into the Bay and anchor.' Oxwich Road (off Bevan Avenue) was christened thus after the pretty village at the western end of Oxwich Bay, also on the Bevan's beloved Gower. The family also had an interest in the building of some of the houses on Singleton Crescent, which they named after Singleton Park, Swansea. When George Bevan Jr's only child, Mary Constance Bevan, who had emigrated to Australia, died in April 2004, she left a request that her ashes should be scattered on the Gower Peninsular.

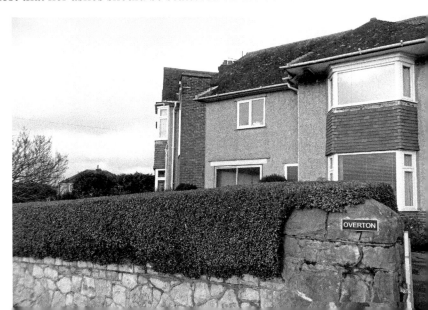

Overton.

Samuel Bond

Samuel Bond ran a successful building business from his premises on Princes Drive. He was born in Middleton, Manchester, and arrived in Colwyn Bay in 1900, believing correctly that the growing town would offer a builder some marvellous opportunities for work. His three sons, Arthur, Fred and Percy, helped him run the business. Arthur was uncertain about the logic of moving to a town that had only one street – Ivy Street. Samuel went to live in Erw Wen Road and called his house 'Middleton Villa'. In an advertisement in 1914 in the local paper he described the firm thus: 'Joiners, Builders, Contractors, Shop and Office Fitters, General Repairers of Property and Greenhouse Makers.' They were also willing to act as funeral directors on the side. They built the Arcadia Theatre on Princes Drive, which a young Sydney Colwyn Foulkes had designed; further down the road they also built Princes Cinema (now a Wetherspoon's pub). Percy's house, Westdale, No. 14 Brompton Avenue, was built by his own firm. Many of the Bond houses are easy to spot because they always added a signature feature to their buildings: the gate posts were invariably constructed using Ruabon red brick, topped with a concrete pediment. Percy's house has this feature, as does the house next door. Crowson Lodge, on the corner of Brompton Avenue and Llannerch Road East, is also distinguished by this feature as is Brantwood on Conwy Road beside the pathway through to Princes Drive. The Bond family were a hardworking lot.

The old Princes Cinema.

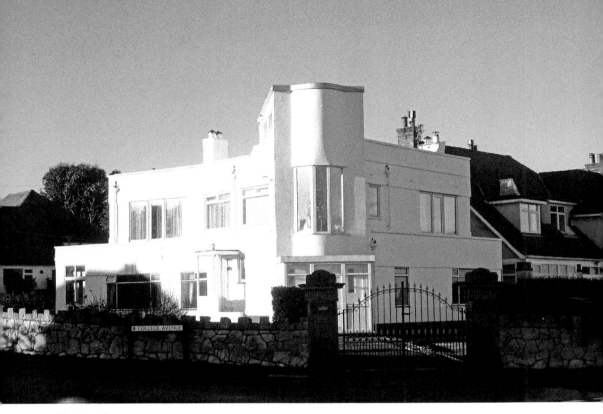

The Breakers.

The Breakers

This is a house at No. 57 Marine Drive, Rhos-on-Sea, on the corner of College Avenue. It was designed, in the 1930s, to look like the prow of ship by Mr William Evans, who also built the house. Mr Evans also designed all the internal fixtures and fittings. It is redolent of the Arts and Crafts movement. Many of the houses on Francis Avenue and Kenelm Road were also built by Mr Evans, who was selling them for £2,500 to £3,500 each – a lot of money at the time.

Bryn Euryn

Bryn Euryn is the 365-foot hill that dominates the background of the town. There is a 360-degree vista from the summit of the surrounding countryside, which makes the fact that this was once the site of an Iron Age hill fort and the spot from which, in the first century AD and led by Suetonius Paulinus, the Romans were attacked while marching below (along what is now Conwy Road) by the unruly hordes of our predecessors, streaming from the summit of Bryn Euryn and the forest around its base, quite obvious.

During the Second World War *Dad's Army*-style reservists were stationed on the summit of Bryn Euryn to keep an open eye on German ships sailing off the coast and planes careering around the skies. Cynlas Goch (Cynlas the Red) in the early sixth century built his fortress on the top of the hill, and the rubble and foundations can still be discerned today. Cynlas was also known as an 'unruly bear' for his uncouth bullying ways. The ancient name for the summit was Din-Arth, meaning the 'Fortress of the Bear' and the road that runs around the western base of the hill is still called Dinerth Road. On the lower slopes of 'The Bryn' are the ruins of the home of Ednyfed Fychan (*c.* 1170–1246). It was from here – Llys Euryn, or as some would have it, 'The Palace of the Golden Hill' – that Ednyfed Fychan ruled an area from Abergele to Conwy. In 2017 Bryn Euryn is a natural recreational area for local people who enjoy its tranquil atmosphere and from the summit of which you get the views enjoyed by the 'unruly bear', cold *Dad's Army* soldiers and Ednyfed Fychan.

'The Bryn'.

C

St Catherine's Church

The church was built 180 years ago as a chapel of ease to Llandrillo. The clergy at Llandrillo-yn-Rhos felt that the people of Colwyn, as Old Colwyn was then known, needed a place of worship in their midst rather than having to walk all the way to Rhos-on-Sea. Eight years after the church was founded it was given its own parish and became independent of Llandrillo-yn-Rhos. The land on which the church was built was given to the church by John Lloyd Wynne of Coed Coch. The church has a distinctive western tower with stepped battlements and pinnacles. The original east window, dedicated to Richard Butler Clough, was given by his widow and illustrated the Agony, Crucifixion and Ascension. In 1892 this was taken out and replaced by a new window in memory of John Matthews Elliot of Rose Hill, Newton Heath. The clock in the tower was installed in 1890 in memory of Revd J. D. Jones, the vicar from 1866 to 1887. The church is now empty and for sale and is a reminder of the passing years and of our changing attitudes to contemporary life.

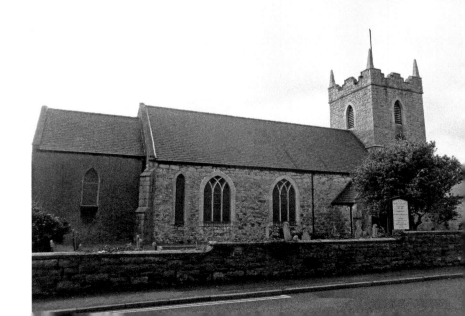

St Catherine's
Church.

Originally the
Cosy Cinema.

Cinemas

Originally there were four cinemas in Colwyn Bay: the Arcadia on Princes Drive, the Odeon on the corner of Marine Road and Conwy Road, the Cosy on Conwy Road in the centre of the town, and the Princess Cinema on Princes Drive. In Rhos-on-Sea there was the Playhouse on Penrhyn Avenue and in Old Colwyn the Supreme was on Cefn Road. The Playhouse and the Supreme buildings are now used by the Co-op, while the Cosy has been transformed into an ironmonger emporium where you can still spy the minute balcony of the old cinema. The Arcadia was designed by Mr Sydney Colwyn Foulkes in the early 1930s for the entertainment supremo Mr Catlin. Mr Foulkes also transformed an old coaching mews, owned by Mr Francis, into the Cosy Cinema.

Coleg Llandrillo Menai

In 1905 the borough of Colwyn Bay established adult education evening courses, initially in the board school in Douglas Road. After a rapid increase in student enrolments it was moved to the Higher Grade School at Dingle Hill, which eventually became home to the grammar school. The numbers continued to rise, so in April 1943 the local authority bought Bod Alaw, a large Victorian villa in Rivieres Avenue. Six years later the whole operation moved to Barberry Hill, which is the present site of the Ysgol Bod Alaw Welsh Primary School.

In 1952, after the Denbighshire Education Committee formally bestowed on Barberry Hill the title of 'Technical Institute', it was christened by local people as 'The Tech'. Engineering, carpentry, joinery, plumbing, gas fitting, catering and

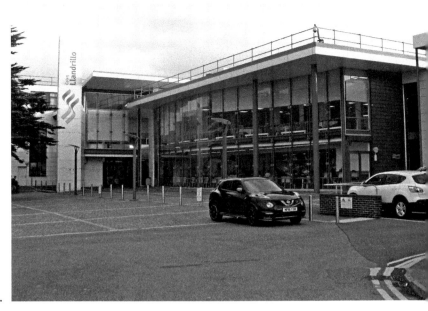

Coleg Llandrillo Menai.

motor vehicle repairing were all on the syllabus. After the Second World War when the borough council were busy building houses and new roads and attracting new industries into Mochdre, the college saw an increasing demand for technical training. By 1960 courses on pre-nursing, hairdressing, food subjects, commerce, radio and telecommunications and many more were on offer. A year later the college supported the Commonwealth Technical Training Week and was given a new name, The Technical College.

In 1963 work began on a new college building, costing £320,000, on the present site on Llandudno Road, and in September 1964 the students moved in. The college was formally opened by the Duke of Edinburgh the following year and has since gone from strength to strength, as evidenced by the opening of a £3.6 million Institute of Health and Social Care in 2010. It is now the pre-eminent centre of adult education not only in Colwyn Bay but also in Wales.

Community Hospital

In April 1897 the inhabitants of the town decided to commemorate Queen Victoria's Diamond Jubilee by building a cottage hospital, to be named the Victoria Jubilee Cottage Hospital. A committee was formed that sent out an appeal for funds to meet the cost of the building. In 1898 the committee bought land on the Ty Newydd estate on what is now Hesketh Road. Each patient, who had to be a resident of the town, had to pay not less than 2s 6d each week. Six doctors from the town agreed to look after the patients. Originally there were two wards – one for men and one for women – with four beds in each ward. In 1907 a nurses' day room, a clinical room and three extra rooms for beds were added. Three years later an operating theatre was added, opened

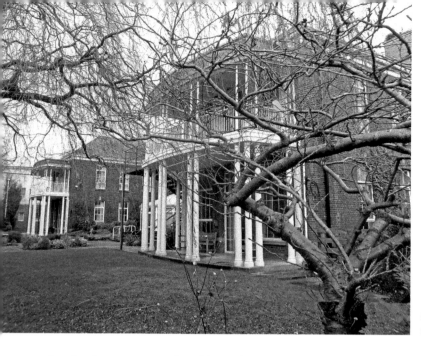

Colwyn Bay
Community Hospital.

by the Countess Dundonald on whose land the hospital stood; it is not recorded as to whether she had to have her appendix removed as part of the ceremony.

After much argy-bargy between the local architect, Mr Sydney Colwyn Foulkes, and the appointed architect, Mr P. S. Worthington of Manchester, the foundation stone of the brand new hospital was laid by Lord Colwyn on 23 June 1923. The fifty-bed hospital was opened on 17 October 1925 incorporating ideas that Mr Colwyn Foulkes had sourced from the USA. Mr Foulkes had eventually been awarded the job of designing the hospital after he had persuaded the committee that they had originally promised him the work and then gone back on their word.

When the site was being prepared for the final building work, a horse and cart drowned in the running sands on the north side of the site. The building work was done by Joseph Davies of Birkenhead in the sum of £24,545 with a £15 per week penalty clause in the case of non-completion. Just before the opening of the hospital Lord Colwyn, chairman of the Executive Committee, took exception to the brass bannisters on the staircase and the blacksmith, Williams of Caernarfon, who supplied them was asked to make them appear bronze-like. In 1929 new X-ray equipment was installed and in 1934 a new nurses' home was opened. This was built by Mr Colwyn Foulkes' favourite builder, Mr Herbert Sandford and his son Sydney.

Council Offices

The new offices on the corner of Coed Pella Road and Conwy Road were built in 2017–18. The council reviewed its office accommodation and realised that leases were about to run out, their buildings were showing severe signs of aging and these buildings were dotted around the borough. In an effort to modernise and be more efficient

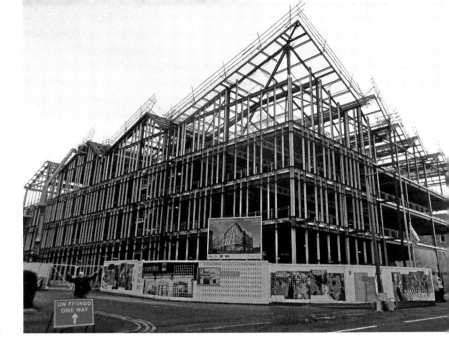

The new council offices being built.

it was decided to bring all their employees under one modern roof. There will be 750 staff in the new edifice, which will replace thirteen existing poorly performing buildings. The Dinerth Road offices, which were used by the Ministry of Food during the Second World War, will close. The expensive exercise is also being carried out to help revitalise Colwyn Bay town centre, bringing people into the heart of the town to add vitality to the community.

It is ironic that this building is being erected on the site of the original Town Hall, which was demolished in the late 1950s because it was showing signs of ageing. Over the years the councillors have had to act like the gypsy travellers of old, first, acting on the vision of town clerk Geoffrey Edwards, moving from the centre of Colwyn Bay to Glan-y-Don Hall near Eirias Park, then on to Bodlondeb on the outskirts of Conwy and so back to the centre of the town. Councillor Norman Cawley, a larger than life character who was the mayor of the town in 1972, took part in the game show *The Generation Game*, hosted by Bruce Forsyth on Saturday evening television. A present serving councillor, Dave Cowans, has climbed the dizzyingly vertical 3,000-foot cliff of El Capitan in the Yellow Stone National Park in America.

Court

The courthouse on Rhiw Road closed its doors on 20 December 1996. It is now home to the Bay of Colwyn Town Council. The plaque by the front door reads: 'This Building was Erected by the Denbighshire County Council for Police and other Purposes AD MDCCCCV11 (1907).' The building was built specifically to house the chief superintendent and his family, the police station and the courthouse. The architect was Walter Wiles, the county architect. It is built in limestone and red sandstone with

The Courthouse.

touches of the Arts and Craft movement. For no particular reason there is a stumpy tower on the top of the building.

In 1974 the Colwyn Bay Bench amalgamated with the Isdulas Bench to form Colwyn Bench and so gained another courthouse in Abergele. In 2001 Colwyn Bench amalgamated with the Aberconwy Bench to form Conwy Bench and justice was then dispensed from the Llandudno Courthouse.

Crematorium

To many people this building holds sad memories of wishing a final farewell to family members and engaging friends. Over the last seventy-one years it has also been a place where people have been able to recall happy memories, sometimes enlivened by laughter, of friends who will be forever recalled with love. The building was opened on Thursday 31 January 1957 by the Right Honourable Earl of Verulam MA, JP, who was the president of the Cremation Society. Reverend David Daniel Bartlett DD, the bishop of St Asaph, blessed the building. Local man Leonard Moseley FRICS, LRIBA, designed the structure and Ashworth Brothers of Rhos-on-Sea built it.

There had been a race between Rhyl and Colwyn Bay as to which authority would build a crematorium first. Colwyn Bay won and Rhyl still does not have such a facility. The roof of the building is covered with Welsh slate, the floor is finished in rubber, cork and terrazzo, the internal walls have wood-panel dados, and in the ceiling are fibrous plaster mouldings that frame the lighting panels set in the ceiling. On the northerly wall is a fibrous plaster bass relief depicting a phoenix, the symbol of resurrected life. Over the years many improvements have been made: a new door by which to exit, more seating, a new office and a modified entrance. In February 1970, the philosopher and mathematician Bertrand Russell OM, FRS, was cremated here and in May 1984 Jack Howarth, who played the character Albert Tatlock in *Coronation Street* was also cremated in Colwyn Bay Crematorium.

Colwyn Bay Crematorium.

Dyffryn

This is a small cottage on Conwy Road in Mochdre. For a while the village post office was next door and that name can still be seen on the house. The ornate iron gates are the original ones from Eagles Farm. The farm was demolished some years ago and the Gwelfryn bungalows have since been built on the farm site. Dyffryn is an excellent example of the architecture of the original buildings that would have lined the lanes of Mochdre 150 years ago.

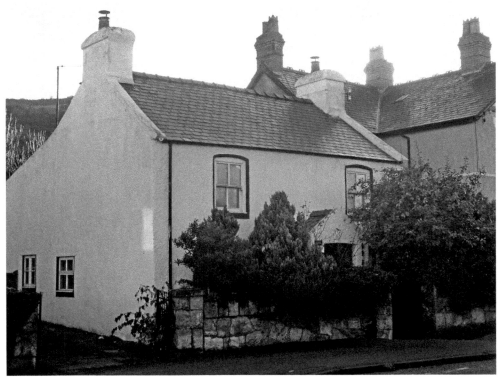

Dyffryn.

Dame Schools

Dame schools were schools run during the 1930s and 1940s in what are now private houses and nursing homes by spinster ladies of a certain demeanour. Miss M. A. Bird (National Frobelian Union Higher Certificate MRST) and Miss U. Hartridge Young ran a 'Select Boarding and Day School', which occupied three large houses over the years: one in Meiriadog Road, Old Colwyn; one on the corner of Kenelm Road and Whitehall Road, still called Chaseley House (now a nursing home); and finally, in a rambling building, The Wings (now converted into flats) on the corner of Abbey Road and Trillo Avenue in Rhos-on-Sea.

The young girls had to wear panama hats in the summer while they were walked in a regimented crocodile line down to the Penrhyn Avenue Park. Other schools of this ilk were Argyle House School on Greenfield Road run by Miss Dorothy Jones and the Leeves Commercial and Tutorial College, which was on the floor above the National Provincial Bank at No. 2 Abergele Road and was run by Miss L. Lindsay.

In the 1935 Colwyn Bay Street Directory there were fourteen private schools recorded. One of these was the Congo Institute on Nant-y-Glyn Avenue where Revd William Hughes taught African boys whom he had persuaded to leave their homes and travel far away to North Wales.

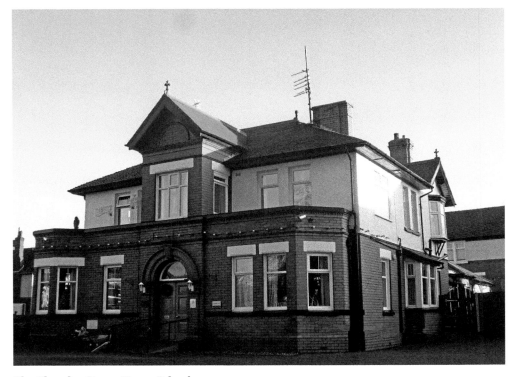

The Chaseley House Dame School.

Eirias High School

In 1903 the first buildings of the school were erected on the present site, named after the park in which it stood. In 1919 it was transformed into a secondary school and in 1935 it became a grammar school, which now has over 1,000 pupils. The head teacher is Sarah Sutton; her two predecessors were Philip McTague and Clive Hampton.

The school today.

After the government's decision to change all grammar schools into comprehensive schools, Ysgol Bryn Elian School was built mainly to cater for pupils from the Old Colwyn area.

There are four houses in the school named after Welsh princes with the addition of a bird's name: Glyndwr Eagles, Llewelyn Hawks, Madog Kites and Gwyedd Falcon. The school now has an up-to-date technology building built by Wynn Construction at a cost of £3.5 million, catering for pupils interested in art, design and technology.

In 1938 there were ten prefects of whom Elwyn Jones is now in New Zealand, Barbara Downs is in Canada and Brenda Westwell is in Rhos-on-Sea. In 1925 Alan Roberts' father took him away from the school because he was being distracted from working by his friend George Mellor. He was sent to the College School on Abbey Road where, on the first day, he bumped into George who had been sent there by his father because Alan Roberts was constantly distracting him from his studies! Well-known people who have been pupils at the school include Alun Michael AM, Heather Willetts the BBC 'weather lady', Steven Morgan who founded the Redrow Construction business, and most important of all, my mother.

Mrs Kenneth Evans

Mrs Evans was the wife of Dr Kenneth Evans from the Rhoslan Surgery, Conwy Road, opposite St John's Methodist Church. Her presence in Colwyn Bay touched the community with the history of the Russian Revolution. She was born on 21 January 1918 aboard a ship while her parents were fleeing from the upheavals that were engulfing Russia, their homeland. She was christened Frances Livia and died in Colwyn Bay Community Hospital on 30 August 1991. Her life had spanned almost exactly the total existence of the USSR, from its inception by Lenin to its extinction under Mikhail Gorbachev. She was an excellent, caring companion to the local doctor. For all of her life Frances Livia retained the Russian inflection in her voice and the good, healthy-looking appearance of a Russian lady.

St Elian's Church

In 1953 Norman Tucker wrote that no spot in the district recaptured 'the atmosphere of the past so adequately as Llanelian'. The church was built on a high mound and commands the village from its distinctive position. The oldest part of the church – the north chapel, where the organ is situated today – dates back to the ninth century. The church today has two equal naves with five bays. In the mid-eighteenth century the church still possessed a thatched roof and whitewashed walls. The church is associated with St Elian, who first landed on the coast of Anglesey in around AD 450. He came from Rome and his name derived from the original – Elianus – thus the spot

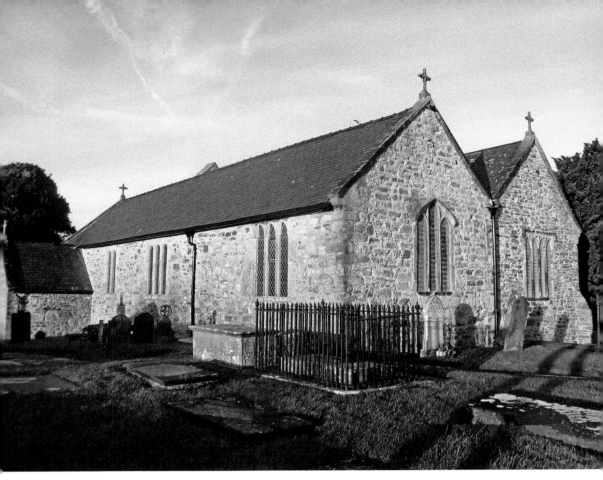

St Elian's Church.

at which he landed is still known as Point Lynus. It is thought that the church was once a sanctuary for criminals and refugees. There is a tombstone in the churchyard dated '1587' that bears the marks of sword and spear, indicating that there was some fighting in the area. The old font, possibly made in the twelfth century, has been placed near the vestry and was found many years ago in a nearby field.

Engedi

This was the Engedi Welsh Calvinistic Methodist Chapel on Woodland Road West. The magnificent building still stands but is now empty, awaiting someone with funds to buy it and alter it or pull it down. The Engedi congregation originally shared a chapel (built in 1873) with the English Presbyterians in a building that cost £700. This building eventually became the Cosy Cinema and is now Mathews' hardware store on

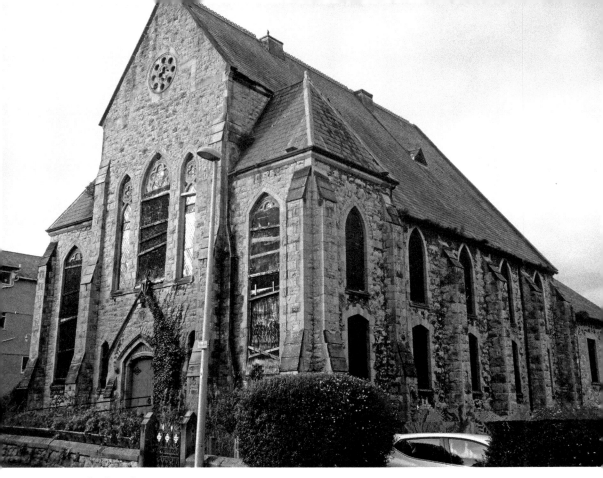

Engedi Chapel.

Conwy Road. Before the building was used as a cinema it was owned by Mr Francis and used as his horse and coach emporium. If you walk down the little lane behind Mr Mathews' store, you can still see the back of the original chapel wall.

The two congregations became so large and the convoluted arrangements for services so tortuous that it was decided that both congregations should have their own new purpose-built churches. The English contingent built their red-brick church on the corner of Conwy Road and Hawarden Road and the Welsh ministers arranged that the imposing stone-built Engedi Chapel be built on Woodland Road West. Engedi was opened in October 1897, three years before Ladysmith was relieved by the British forces in the Boer War and only twenty-one years after General Armstrong Custer had been killed at the Battle of Little Big Horn in America. The chapel was built by local builder John Roberts of Fern Bank and remained a place of worship for the following eighty years. The interior was beautiful: full of well-polished wood, well-crafted pews, a high ceiling and a magnificent amphitheatre curved gallery.

English Presbyterian Church

This congregation used to worship in a small chapel where Matthews' hardware store now stands, which they shared with their Welsh friends. Both congregations grew so large that the Welsh community built Engedi Chapel on Woodland Road West and the English lot built the lovely Ruabon red-brick church on the corner of Abergele Road and Hawarden Road. In July 1890 the foundation stone of the new church was laid, and one year later the completed edifice was opened by Principal Thomas Charles Edwards DD of the University College of Wales, Aberystwyth. The imposing octagon spire rises to a height of 70 feet, the steps are made from Yorkshire stone and the roof is supported by clear-space hammer-beam principals.

Numbers rose steadily until the explosion in attendance figures during the Second World War with the arrival of 1,000 evacuees and 5,000 Ministry of Food civil servants into the town. Inevitably, after these people left once victory had been won, the church community found it difficult to adjust. There were also problems in finding ministers and after Revd W. O. Jones left in 1989 the congregation had to struggle on without a minister. The church closed for use by the English Presbyterian cause in 2007 and has now been purchased by the Woodhill Baptist Church congregation.

Esperanto

In the 1902 edition of the *Adresaro de Esperantistoj* (a collection of addresses of the early speakers able to converse and write in the Esperanto language) is the name of Miss E. Lloyd. She was the daughter of Edward Lloyd, who owned a chemist shop called Morfan on Conwy Road (opposite the present site of Barclays bank). It cannot have been a thriving business as there were not many pills and potions on the market in 1902 and Miss E. A. March also ran her milliner's business from the same premises. Two other ladies in Colwyn Bay, possibly friends of Miss Lloyd, were experts in the language and appear in the *Esperanto Director*: Elizabeth Selbie, who lived at Glen Holme on Abergele Road, and Alice Ayles, who lived in the boarding home Arvon House on East Parade. The three young ladies held their interest in Esperanto with people in Moscow, Paris and Olomouc in the Austro-Hungarian Empire. One hundred and fifteen years later we are told that we live in an ever-expanding internationally connected world, but in a time before television, telephones, computers, record players and central heating, Lloyd, Selbie and Ayles were ahead of their time, already connected to the wider world by a secretive concocted language.

Miss Lloyd lived here in 1902.

Farms

By 1815 many of the things that make life agreeable for humbler mortals had just arrived in their modern form, such as passable roads, tea and street lighting. The farms in the town were built in this peaceful enclave during a time when vast armies, maintained by taxes deliberately designed to weigh mainly on the poor, roamed through Europe. At the turn of the eighteenth century expectation of a long life was low and the Colwyn Bay farms were maintained by men and women who lived at subsistence levels, confined by narrow physical and intellectual horizons. Now, in 2018, that we seemingly have everything mortal man should need, all the farms are gone except for Peulwys, Pentre Uchaf and Ty Mawr Farms in Llysfaen, Hafodty Farm in Upper Colwyn Bay, Cae Gwyn Farm in on Conwy Road, and Mochdre and Dinerth Hall Farm in Rhos-on-Sea. The rest are gone, but in many cases the farmhouses remain and are now family homes. Tan-yr-Allt Isaf and Tan-yr-Allt Uchaf in Mochdre have been turned into pleasant dwellings and the adjoining fields are now covered by houses. Tyn-Rhewl and Plas Newydd in Rhos-on-Sea have been family homes for many years. The house on Dolwyd Farm still looks like a Welsh whitewashed

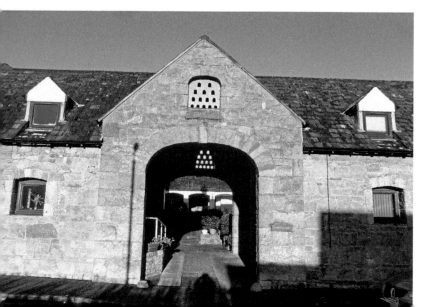

The converted Bryn Euryn Farm.

farmhouse but is no longer surrounded by a farm. Bryn Euryn Farm's house is tucked away on Tan-y-Bryn Road, the farm buildings having been transformed into sheltered housing. Rhyd Farm in Rhos, and Berth-y-Glyd and Rhuallt Farms in Old Colwyn have been demolished.

Sidney Colwyn Foulkes

Mr Foulkes was seventeen years old when he designed a theatre for Mr Catlin on Princes Drive and an open-air theatre beside the old, now demolished, Colwyn Bay Hotel. He did this before he was qualified as an architect. After qualifying, instead of spreading his wings in larger metropolitan areas of the country, he returned to Colwyn Bay and set about designing numerous high-quality buildings that we still see today: Woods Department Store on Station Road, the Old Colwyn war memorial, the Rydal School buildings on the corner of Lansdowne Road and Queens Road, Old Colwyn United Reformed Church, St John's Church rooms and theatre on Cliff Gardens, St Cynfran's Church rooms, Llysfaen, the Eventide Home complex on Norton Road, the Bethel Welsh Chapel on Miners Lane, the housing estate between Elwy Road and Llandudno Road, and many private homes such as the Wren's Nest on Lansdowne Road.

The Eventide Homes, Heaton Place.

Garstangs

This was a family-run wholesale fruit and vegetable business located on Penrhyn Avenue in Rhos-on-Sea. Mr Garstang, always referred to as 'the old man', had twenty-three wagons including articulated lorries – many were Ford Thames Trader Flatbeds and one was a 16-ton Bedford Flatbed. All these vehicles were kept in tip-top condition by the mechanic known as Harry 'boots'. The 16-tonner was driven exclusively by a mountain of a man with arms as thick as trees, called Big Ray. He was famous among his colleagues for being able to eat an apple despite having no teeth whatsoever. Ray lived on the Glyn estate next door to Geoffrey Jones, who had been a prisoner of war and became the back-room boy at the crematorium.

At the crack of dawn all the wagons would be driven to the market in Liverpool, where they would pick up the fruit and vegetables from Tommy Ryan's at Lydiate. The produce would then be distributed to the greengrocers all over North Wales. It was a slick, well-oiled operation. The large depot was built around 1950 but when the smaller shops were closing and the large supermarkets and Marks & Spencer's began to operate, Garstangs found it more and more difficult to compete. Eventually the depot was demolished in the late 1970s and the Rhos Manor apartment block was built on the site.

St George's Church

The foundation stone of this church on the corner of Allanson and Crossley Roads was laid by Sir Watkin Williams Wynn Bart on 26 February 1913. The population of Llandrillo-yn-Rhos had risen dramatically in the previous twenty years so the church was built to cope with this demand and relieve the pressure on the parish church. It was envisaged by the architect, Mr L. W. Barnard, that there should be a rather ornate vaulted tower. Due to the two world wars and a lack of funding, the church had no tower until 1965. George Mellor, who lived opposite the church on Crossley Road, was

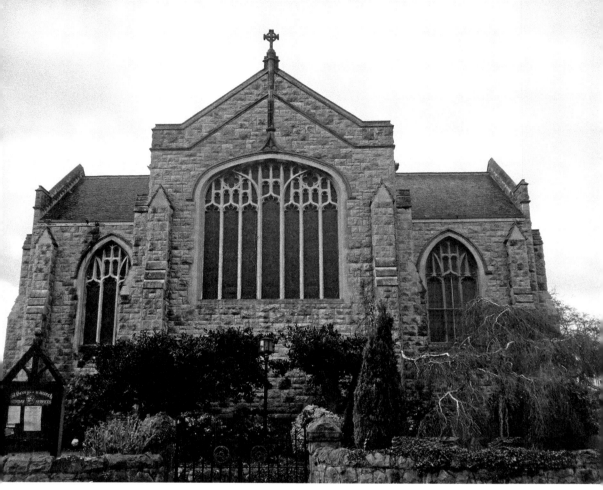

St George's Church.

convinced the cross that had been placed on top of the tower was crooked. The vicar, curate, organist, architect and builder all went to see him. They invited him to peer through a theodolite to convince him that the gold cross within its circle was in fact dead centre and upright.

Glan-y-Don Hall

This imposing hall was built originally as a private residence in the fields between the old township of Colwyn and the new township of Colwyn Bay, and stands today in 32 acres of formal gardens. It is a Georgian design with a painted white edifice and was rented in 1878 by the Cheadle Royal Hospital. The hospital authorities bought it in 1907 and opened it in 1911 as psychiatric home. It was for men and women of all ages and known by the locals as the hospital's 'Seaside Branch'. The town council

bought the building after the Cheadle Hospital trustees took stock of their building needs. On 14 May 1964 it was officially opened as the Colwyn Bay Civic Centre. A few years later the local authority sold off a chunk of the Glan-y-Don land to the North Wales Police, who built their headquarters on the site in the early 1970s. In July 1971 the Duke of Edinburgh called to check on the progress of the building; it tickled the duke's funny bone no end to discover that the twenty-two constables, one sergeant and one inspector who lined up as his guard of honour were all called Jones.

Glan-y-Don.

Hudson Memorial Church

This church stands on the corner of Sea View Road and Abergele Road and is now derelict. It was originally a Congregational Church, then a Union Church and ended up as a United Reformed Church. The land was purchased from the Pwllycrochan estate in 1874 and at first the congregation met in an iron shed on this spot. The building cost £2,450 to build and was dedicated to the memory of a worthy Christian man, Mr R. S. Hudson of Chester. It was formally opened for services on 23 September 1885. Due to increasing demand, in 1901 a further £4,700 was spent on seating

The church in 2018.

accommodation, several classrooms and a lecture hall, which was used as a canteen during the Second World War. The first minister of the church, Revd Thomas Lloyd, was paid a stipend of £100 per annum.

Harlequin Puppet Theatre

The theatre, the only one dedicated to puppetry in Great Britain, was opened on the promenade on 7 July 1958. It was the brainchild of the late Eric Bramhall, a genius in the art of puppetry, and Minnie Ford, who was the owner of Aberhod. The theatre was constructed from the remnants of Miss Ford's outhouses and a derelict cottage at the back of Aberhod. Two brick arches that were part of the cottages were incorporated in the wall of the theatre. Mr Bramhall and his associate Chris Somerville met Miss Ford, who threw herself enthusiastically into the productions and gifted them the site for their theatre. The building won a Civic Trust Award and Mr Somerville is still producing excellent shows in this jewel of a theatre.

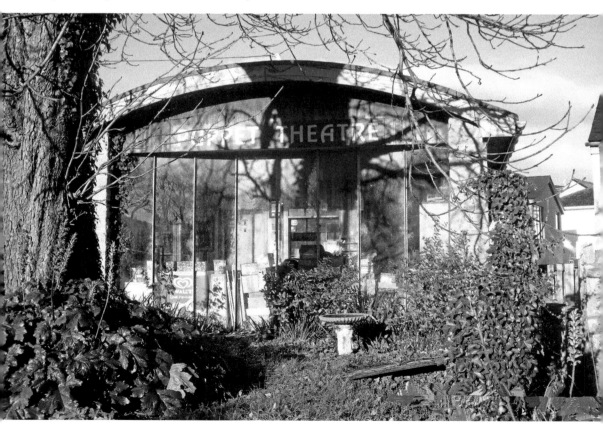

The Rhos-on-Sea Harlequin Theatre.

Donald Wynn Hughes

Mr Hughes was the inspirational headmaster of Rydal School. He died on 3 August 1967 following injuries received after an accident. He was the son of Dr Maldwyn Hughes, the first president of the Methodist Conference. He was educated at the Perse School and Emmanuel College, Cambridge, where he gained a first-class degree in English. He was an assistant master and housemaster at the Leys School from 1934 to 1946 and succeeded Revd A. J. Costain as headmaster at Rydal School in 1946. Personally, I will always remember him as a great teacher who was able effortlessly to stimulate the minds of young boys. He was a consummate after-dinner speaker, pricking the balloons of pomposity. As well as his responsibilities at school, he was a magistrate, member of the Hospital Management Committee, chairman of the Colwyn Bay Council of Churches, president of the North Wales Cricket Association and a president of the Rotary Club. The extra mile was always in his day's journey. In the last sermon he was able to deliver to the boys at school, at the end of the summer term, he closed with these words: 'It is within the powers of us all to realise our true selves, not by greed and self-seeking, but in the service of our God and of our fellow men.'

A painting of Donald Hughes by Stanley Reed (1908–78). (Reproduced by kind permission of the Williamson Art Gallery and Museum, Birkenhead: Wirral Museums Service)

Imperial Hotel

This large hotel, built in the early 1900s, stands on the bottom corner of Station Road alongside Princes Drive. For many years the Imperial Hotel and the Station Hotel were the only buildings on this side of the road. Between them were fields where cattle grazed. The Station Hotel later became known as The Central, but has now reverted to its original name. The Imperial, always known as 'The Imp' by locals, was built in the heyday of the town's use as a holiday destination. It formed a triumvirate with the Pwllycrochan Hotel and the Colwyn Bay Hotel, its location right opposite the railway station being a major selling point. In 1939 it was taken over by the Ministry of Food, along with all the other hotels in the town. The Merchant Navy Control Department

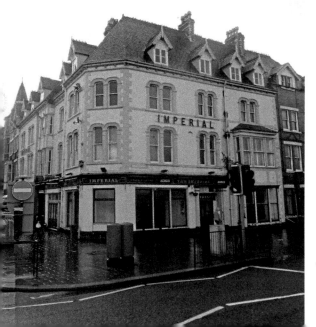

The Imperial Hotel.

had offices in the hotel where they monitored the travel of the merchant ships arriving and leaving Liverpool docks. Sometimes, though, there was much sadness when the civil servants realised that a merchant ship laden with vital supplies had been sunk by German submarines, with the loss of valuable lives. After the war the hotel never returned to its former glory and it has struggled – and is still struggling – to find a new role in a different world.

Ivy House

Ivy House was the first house built in Colwyn Bay on the corner of Ivy Street and Abergele Road. Ivy Grove, No. 2 Victoria Park, is called thus because former owner Miss Enid Louisa Dowell was the granddaughter of Thomas Hughes (1819–91), who built Ivy House. Mr Hughes was a farmer from Maenan, Llanrwst, and attended the sale of Lady Erskin's estate in 1865. He bought the corner plot opposite Woodland Road East and built his home and a small grocer's shop and general store on the ground floor. He named it Ivy House after Plas Iorwg, his former family home. He grazed a herd of cows across the road on Erskine land, where St Paul's Church now stands. His grandson, also named Thomas Hughes, died during his year of office as the mayor of Colwyn Bay – 1943.

Colwyn Bay's first house.

St John's Methodist Church

The foundation stone of St John's Church was laid in 1882 and then all building came to a standstill until 1887 when the project was completed. In the intervening five years the site became known as 'Wesley's Folly'. The hiatus was the result of a lack of funding.

The church stands in its own ample grounds on the corner of Conwy Road and Pwllycrochan Avenue. In the 1870s 'The Watering Places Fund' was opened by Revd Dr William Morley Punshon and Revd Frederick Payne, with the vision of building Methodist churches along the North Wales coast. Colwyn Bay was chosen by these two gentlemen because they considered it a beautiful place, which, in due course, would attract a lot of people. The Manse, Tranby, was also built on the land next door, but is now a nursing home. All the buildings cost £10,450 to build. The site is almost unique in Methodism, containing within it all that was necessary for church life: the building in which to worship, the home of the minister, the schoolroom for education and the room in which refreshments could be prepared and eaten.

The church was built by Mr Edward Foulkes. His son was baptised there and at the last moment, just as the holy water was going to be sprinkled on his forehead, the

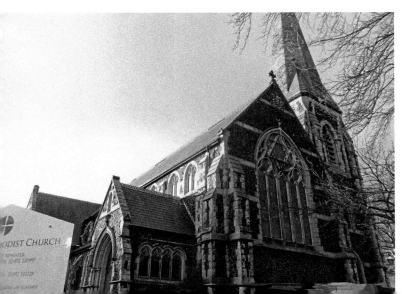

St John's
Methodist Church.

minister realised that the parents had not chosen a second Christian name for the baby and exclaimed to them that they had better very quickly choose one. Flustered, his mother said, 'Oh, as we live here, you had better say Colwyn then'. He thus was christened Sydney Colwyn Foulkes.

St Joseph's Roman Catholic Church

In 1895 Colwyn Bay had been assigned a resident priest who conducted services in a private house in Rhiw Road and in two local hotels. Dr Mostyn, the bishop of Menevia and later the Archbishop of Cardiff, laid the foundation stone of St Joseph's on the corner of Conwy Road and Brackley Avenue on 10 August 1898 – the same year the embryo church was put in charge of the Oblates of Mary Immaculate. Two years later the church was completed, on land bought from the Pwllycrochan estate, when it was blessed on Whit Sunday (3 June 1900). The funds for the project were donated by Monsignor James Lennon in memory of his brother, Dean John Lennon. There are memorial plaques to both men in the church.

It was designed by Mr R. Curran, who had originally designed a steeple to top the structure but was persuaded that a tower would, for some reason, be more appropriate. Because of its lack of height, there is speculation that the tower was never finished. The church is built using red and yellow sandstone; red for the details such as window and door openings, and yellow for the walls. In 1905 the Catholic hierarchy opened the Convent of Mercy on Walshaw Avenue under the supervision of Father Comerford. This was a nursing home for the use of non-Catholics as well as practicing Catholics, built as an appendage to the convent in the 1970s. In November 2017 it was bought by a private, non-Catholic organisation and is now known as 'The Old Convent Nursing Home'. A school for the children of Catholic parents was built next door to the church and opened in January 1933.

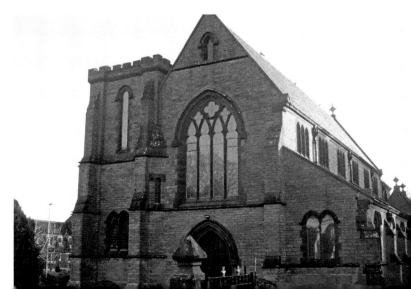

St Joseph's Church.

Kennedy Court

Kennedy Court, on Llanelian Road in Old Colwyn, is local authority social housing at its best and was named after the assassinated 35th president of the United States of America. It was designed by Brian Hallwood Lingard DA (Manc) FRIBA. It was officially opened on 23 June 1966 – three years after the killing – by the Hon. Willis C. Armstrong, Minister for Economic Affairs at the Embassy of the United States of America. Mrs Vera Naylor was the mayor and Geoffrey Edwards was the town clerk. It was a completely new build, made within the confines of a local authority budget. The development takes up the whole of the area encompassed by the apex of the

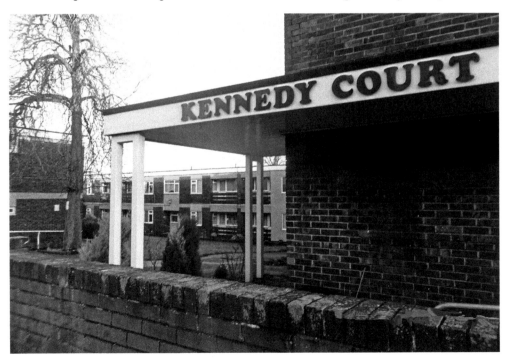

Kennedy Court.

land that is enclosed by Llanelian Road and St Catherine's Drive. A large property called Colwyn House used to occupy the site, but by the 1950s it had become a rabbit warren of habitation where lots of people were living in various degrees of squalor. The land on which Mr Lingard's creation stands slopes down from Llanelian Road to St Catherine's Drive, so that as one walks up the Drive, Kennedy Court stands aloft like a modern version of a medieval castle. The structure has two floors and a delightful grassy courtyard around which cluster the flats. I doubt that Mrs Kennedy would have wished to live there, but it might have appealed to Lee Harvey Oswald.

Kyrtonia

No. 5 St Paul's Close (opposite the police station) was for some time the home of Ian Curry Hughes, who was born in Eagles Farm, Mochdre. His father gave him his middle name because Dr Curry had delivered him into the world in Nant-y-Glyn Maternity Hospital. The house is called Kyrtonia because the original owner, a long way from home, had fought at the Battle of Kyrtonia during the Gallipoli Campaign in 1915.

Kyrtonia.

The Lamp

The ornate cast-iron lamp standard at the top end of Station Road was a prominent landmark for many years. It was taken down in the late 1960s as it was considered an impediment to the regular passage of motorcars. This was not so, but the road is now pedestrianised anyway. Newspapers were sold from this spot by a man who wore women's high-heeled shoes and hollered his head off, shouting out the headlines to advertise the fact that he had the papers to sell. For many years the spot was used by the local police force as a central point from which they managed the running of the town. During daylight hours there was always a policeman stood beside the lamp. Before the police were equipped with radios, if the on-duty sergeant in the police station in Rhiw Road was informed during the night that there was trouble in the town he would leave the station, lock it up, walk to the lamp and switch off. The patrolling police constable, seeing from afar that the lamp was unlit, would hasten to meet his sergeant and they would endeavour to sort out the local miscreants.

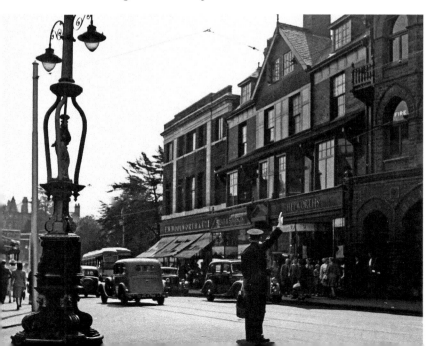

The Station Road lamp.

Llandrillo-yn-Rhos Parish Church

This church gave birth to St Paul's Church in Colwyn Bay and St Catherine's and St John's Churches in Old Colwyn. The name Llandrillo (perpetuating the name of the patron saint, St Trillo, whose festival is on 15 June), started to be used in the sixteenth century. The church was in existence well before then but had been called Dinerth Church as far back as AD 819. The font is thought to be Norman and the Rhos Fynach charter of 1230 has a clause requiring Ednyfed and his heirs to pay yearly 'to God and the Church of Dineyrth two shillings towards lamps at Easter-tide'. The two bricked-up archways in the north wall may well be all that remains of Ednyfed's chapel. The north aisle is the earliest part of the present building and was built in the thirteenth century. Hugh Conway's will, dated 1540, mentions the building of a chancel and porch. The Conway family were also responsible for building the south nave and tower, which incorporates a 'Rector's Chair' at the top. Antiquarians who inspected it in 1848 regarded it as a 'beacon turret', which would have acted as a lookout and signalling post. Beside the path under the east window is the tombstone of Margaret Conway, who died on 13 October 1654. The existing east windows were a thanks offering from Mr Edward Brooks of Pabo in 1873 on his recovery from a long illness. Sir Stephen Glynne visited the church in the 1850s and wrote that it was 'rather more imposing in appearance than the generality of Welsh churches'.

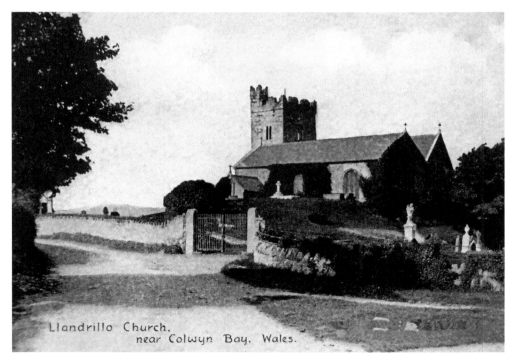

Llandrillo-yn-Rhos Parish Church.

Llysfaen

The village is part of the Colwyn Bay conurbation whose village councillors sit on the Bay of Colwyn Town Council. The name 'Llysfaen' is Welsh for 'stone court'. It stands prominently at the top of the hillside, rising from the seashore halfway between Abergele and Colwyn Bay. The patron saint of Llysfaen is St Cynfran, who is thought to have founded the church in the village in 777 and whose likeness can be seen inscribed into the stonework above the entrance to the church.

In 1699 Lhwyd found only 'two or three houses by the church' when passing through on his way to Conwy. One hundred and thirty four years later a Mr Lewis reported that the village consisted 'of five houses only'. On 1 November 1898 an application was made by the parish council to the Caernarvonshire County Council (under which bailiwick the village then sheltered) requesting that Llysfaen might become an urban district. The prime reason for this request was the inadequacy of the water supply in the village.

It is reported in the church memorandum book: 'Large numbers of donkeys in Llysfaen in early part of 19th Century. Strings of donkeys used to carry coals and merchandise up to Llysfaen at 1d and 2d per cwt. The donkeys used to follow each other so as to form an Indian file of about 20 to 30.' There is a holy well, the Ffynnon Gynfran, around 100 m north of the church. Today, besides the church, there is a primary school, convenience store, village hall (designed by Sydney Colwyn Foulkes), playground and three parks, as well as a football pitch known locally as the 'Banana Pitch' because it dips markedly in the middle.

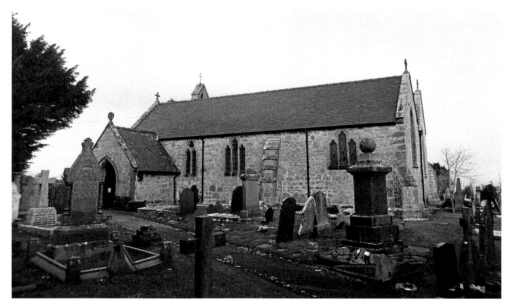

St Cynfran's Church.

M

Magistrates

It was only in 1930 that magistrates of the Colwyn Bay Court began to sit regularly once a week at 10.30 a.m. on Wednesdays. Over the years the list of magistrates has been a compendium of people who served the community with distinction and honesty. Geoffrey Gadd was the senior partner of Aston, Parkinson & Gadd, the local chartered accountants, and was the chairman of the bench for many years. Dr Eileen Davies and Dr David Meredith were respected members of the caring services, Brian Pinn ran the Hopeside Hotel, Mrs Elizabeth Colwyn Foulkes was a prominent architect, Donald Crook and James Barry were both wonderful teachers, Merfyn Lloyd was a bank manager in the town for many years, Bill Meredith (with his brother John) ran Meredith & Kirkham Garage in Old Colwyn and Menai Bridge for thirty years, while Brian James was the owner of the Dingle Garage. Lionel Johnson owned the Rhos-on-Sea Laundry, Graham Roberts was the local funeral director, and Charles Crump, who arrived in the town as an evacuee during the Second World War, was the deputy borough clerk.

Colwyn Bench, 2000.

The Justice of the Peace Act was introduced in 1361. This was the first use of a Justice of the Peace, who had to be a worthy member of the community in England, a privilege extended to the people of Wales in 1536. In 1552 there was the first recorded crime in Colwyn Bay, which was dealt with at Caernarfon quarter sessions, and in 1898 it was decided that Colwyn Bay should have its own petty sessional division.

Marbury

Marbury and Sedburgh – Nos 9 and 11 Llysfaen Road, Old Colwyn – are two imposing houses built side by side on a prominent natural shelf at right angles to the road. They were built in 1925 by Mr Ellis and given to his daughters, who lived happily next door to each other. Some years later Marbury became the home of Henry Wiggin Jones, who ran a painting and decorating business from a shop at No. 79 Abergele Road, close to the present site of Cambrian Photography. It was Mr Jones who named the house Marbury, as he did the shop on Abergele Road. He did this because he and his family had come from the village of Marbury, in the agricultural area of Cheshire. It was not until 1930 that water was piped into the houses in the village, where cheese-making was the main occupation, so the Jones family came to Colwyn Bay to seek a better standard of living. The two homes on Llysfaen Road had extensive grounds with a tennis court on the lawn, on which another house has now been built. On the steps, in the garden of Marbury, still to this day are the inscribed letters of the original owner and his two daughters, 'R. E. E.', 'J. E.', and 'E. E.'.

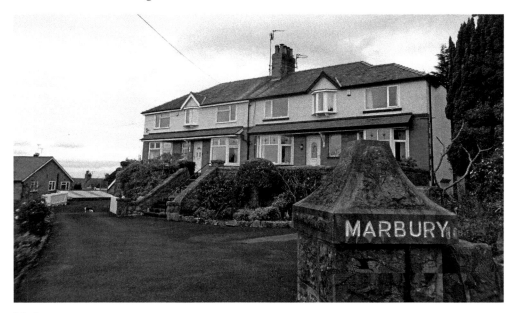

Marbury.

Masonic Lodge

The Masonic lodge on Bay View Road has been the home to hundreds of masons over the years. There are four Craft lodges – St Trillo (consecrated on 18 September 1895), Sincerity (consecrated on 18 August 1922), Derwen (consecrated on 3 December 1955), and Colwyn (consecrated on 30 January 1960) – and other types of lodges, all of which meet here. In days gone by, at the beginning of the Masonic year (September) the members of each lodge would parade through the town in their full regalia. Sincerity Lodge closed down in 2018; Tom Wyatt was the last Worshipful Master. A prominent member of the Craft in Colwyn Bay was Alvin Langdon Coburn. He was an internationally well-regarded photographer who wrote a pamphlet in 1961 entitled 'Beyond the Craft'. The Masonic movement has been a force for good in the community and has raised an enormous amount of money for local causes. Years ago at the meals in the Metropole Restaurant after the meetings, three of the senior Masons – Philip Arundale, Tom Tilling and Revd Aneuryn Jones, who the other masons nicknamed, Shadrach, Meshach and Abednego – would watch over the proceedings, gimlet-eyed, to make sure none of the junior Masons strayed into behaviour and language that they deemed to be inappropriate.

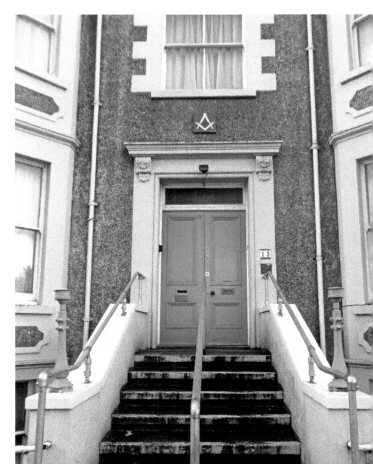

The Temple building.

The Miami was here.

The Miami

This was a café on the corner of Abergele Road and Douglas Road, opposite the Prince of Wales Theatre, in a building built in 1906, where generations of young people in the town in the 1960s and '70s spent an awful amount of innocent time over a frothy coffee. It was the Expresso Bongo café of Colwyn Bay, where 'old' Bill Fielding ruled the roost, well before there were lattes, cappuccinos, flat whites, mochas and Americanos; happy, uncomplicated days when you had to arrange to meet someone at the café without the use of a mobile phone and then have a raucous conversation without being interrupted by the same instrument. Fifty years later, there is still a coffee house on the premises.

Ministry of Food

In 1940 5,000 Ministry of Food civil servants descended on the town. They commandeered every hotel and every building used by the two large public schools, Penrhos and Rydal. Every home that had a spare bedroom had to be used by a civil

The Mount Stewart Hotel, home to the Wheat Division.

servant for 1 guinea a week. They were henceforth known as Guinea Pigs. All the schools had to go onto a half-day routine: half a day for local children and the other half for the children of the civil servants. The new maternity hospital on Nant-y-Glyn Avenue was bursting at the seams as it accommodated the pregnant wives of these new arrivals, to such an extent that the establishment became known as the Swell Hotel. The cinemas did a roaring trade and there was a busy roster of shows in the Pier Pavilion. All the while the local people tried to hide the black market activity from the Ministry of Food snoopers, but no one seemed to blab and the market thrived with all the surrounding farmers doing good business. The social life of the town was vibrant, with dances, football matches, cafés and churches all being well attended. At the same time, the civil servants were beavering away under the benevolent eye of the Minister of Food, Lord Woolton, to ensure that the people of these islands did not starve during the vicissitudes of the war. The whole thing was a marvellous success. Hitler never discovered what was going on and at the end of it all some of the male employees of the Ministry nipped off home to Guildford with Colwyn Bay girls as their wives.

Mochdre

Mochdre is an ancient village that was in existence well before Colwyn Bay became the dominant township of the area. The village is now a suburb of Colwyn Bay with its own post office, school and business estate. Mochdre is mentioned in the Survey of the

Honour of Denbigh in 1336. The legends of the *Mabinogion* explain that a swineherd called Gwydion passed through Mochdre on his travels in Wales. The Old Highway delivered the Romans to the village on their way to subdue the unruly savages of Anglesey. It also lay strategically, as it still does, on the track between Rhuddlan Castle and Conwy Castle. In the nineteenth century the Swan Inn, opposite the Mountain View, acted as a watering hole for travellers journeying by coach and horses. The old Swan Inn still has a replica white wooden swan attached to the chimney. At the bottom of the Old Highway was a convenient smithy. The village stands in the middle of farming land that once sustained six farms; only one is still in operation. In June 1887, the villagers rioted against the imposition of tithes or taxes on the produce they grew, a law which said a tithe was due to the vicar of Llandrillo-yn-Rhos Parish Church. As such, they were instrumental in gaining the abolition of the tithe. As Welsh-speaking Nonconformists, they resented paying a tax on the fruit of their own labour to an English-speaking vicar of the Church of England. Soldiers were sent to the village and a little blood was spilt before the unpleasantness was resolved in favour of the farm owners and the workers. The village used to have its own railway station, which was run by a stationmaster with one good leg and one wooden leg; it closed in 1931, much to the relief of the stationmaster and his one good leg.

Mochdre.

N

Noddfa

No. 43 Mind-y-Don Avenue, No. 13 Wellington Road, No. 43 Penrhyn Avenue and No. 12 Craig Wen are all called Noddfa. Noddfa is the Welsh name for a refuge, shelter, sanctuary or, as some believe, an asylum. It is an obvious Welsh name for a home. Noddfadigion is a place of refuge for an evacuee. During the Second World War there were many hundreds of evacuees from Liverpool in Colwyn Bay and the surrounding area. Some of these children were given sanctuary by Mr and Mrs Wyatt in their home in The Close in Colwyn Bay and some were looked after by Mr and Mrs Scollon in Abergele. Many years later when Mr and Mrs Wyatt's son married Mr and Mrs Scollon's daughter, they went to live in Craig Wen in a house that they naturally named Noddfa.

Noddfa.

The Oak

On 14 August 1934, George V approved the incorporation of Colwyn Bay as a municipal borough. The seal of the council had been dominated by the image of an oak tree, something that was retained in the new coat of arms. In the 1987 Colwyn County Borough Annual Report mention is made that in the base of the blazon is 'issuant an oak tree proper fructed' – whatever that means. The charter mayor, Lord Colwyn, planted an oak tree in Eirias Park to salute the event. Another oak tree was planted to commemorate the coronation of George VI and another by Alderman Leonard Firth on 2 June 1953 in honour of coronation of Elizabeth II. On the title page of Norman Tucker's book about the town, *Colwyn Bay Its Origins and Growth*, there is a drawing of the coat of arms and beneath it is the quotation from a *Display of Heraldry* (1623): 'The Oake is the strongest sort of Trees, And therefore may best challenge for first place.' The tree lent its name to the Four Oaks Restaurant in Eirias Park, Oak Drive

The Oak on the old county boundary.

and also to Oak Drive Close. In December 1991 a group of eight-year-old children from Ysgol Bod Alaw planted fifty oaks in the school grounds, assisted by the headmaster, Mr Llew Williams, and Clwyd County Councillor Mrs Doris Griffiths. In the same year the mayor, Councillor Brenda Taylor, planted an oak tree in the lawn of the Glyn estate.

Old Highway

This is the ancient highway through the town, which in fact bypasses the town, running below the woods and above the land owned privately by the landed gentry. It starts beside the Groes River and continues past the present entrance to the zoo, to Tanrallt Steet in Mochdre, and so on to the Conway Ferry. It is an ancient military road between Rhuddlan and Conwy, and at the beginning of the seventeenth century traffic would pass along it only occasionally. It would have been no better than a rutted lane, narrow with high hedges on either side. In the early 1600s there would not have been a thousand souls in the entire parish of Llandrillo-yn-Rhos, with very little reason to travel anywhere. The main bridge was, and still is, over the Groes River. In the 1616 petty sessions levied £10 towards the repairing of the highways. It is now used by knowledgeable local people as a short, uncluttered road, to almost anywhere in the parish.

The Old Highway.

Frederick Gordon Parkes

In the 1890s Mr Parkes was the first electrician in Colwyn Bay. He was born in 1870 and was working on the docks in Liverpool when he saw an advertisement in a newspaper for an electrician to work for Rowland Jones in Colwyn Bay. Mr Jones had bought a generator and gas engine and had installed them at his premises in the building between Theatre Colwyn and Tabernacle Chapel on Abergele Road. There was no electricity in Colwyn Bay at this time. Mr Parkes applied for the job and got it. The first work he completed was to install electricity in the shops running down the side of Abergele Road, from the Theatre to the Union Church, on the corner of

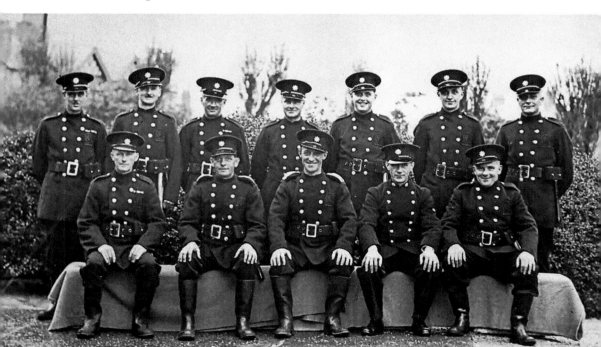

Mr Parkes: middle of front row.

Sea View Road. Mr Parkes remembered when the fire station was in Ivy Street. The fire tenders were drawn by horses, but they did not possess any horses of their own. When a fire was announced the men would run out of the station, stop the first horse they came across, immediately deprive the owner of the beast and put it between the shafts of the water carrier then charge off to the fire.

Parciau

This area on the edge of Old Colwyn is still open land. It acts as a natural geographic break to the development of the town. There is open land all the way over the hill to Groes Road and south to Llanelian Road. The land was once owned by Mr and Mrs Stott and it was their daughter, Miss Muriel Stott, who gave the land to the National Trust. She gave the hall (No. 100 Llanelian Road) to the Abbeyfield Society and sold the lodge at the entrance to the driveway, which had been used by her chauffeur/gardener. Abbeyfield has now sold the hall. Muriel Stott died on 26 March 1975, having been saddened to see Bryn Elian School built on a piece of her once open green fields.

View from Golf House, Old Colwyn

Parciau farm.

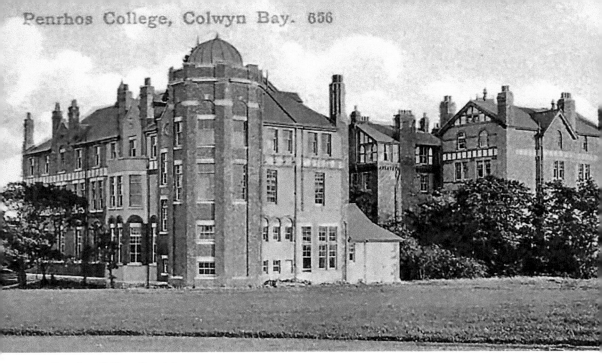

Penrhos College for girls, c. 1930.

Penrhos College

This was a girls' boarding school until its amalgamation with Rydal School. It was in 1895, when there were only thirty-five girls in the school, that the governors bought the hydropathic establishment (with all its contents) from the Pwllycrochan Estate Company. They inherited a Turkish bath with the buildings, which was transformed into cloakrooms and an area for piano practice. During the Second World War, when the buildings were requisitioned by the Ministry of Food, the school decamped to Chatsworth in Derbyshire, the home of the Duke of Devonshire. All the buildings were demolished in 2001 and the land is now covered by a housing estate.

The Pier

Colwyn Bay's pier was opened on 1 June 1900, and was named Victoria Pier in honour of the queen. Maynall & Littlewood had been the engineers and Widness Foundry Co. were the contractors. It was constructed by Messrs William Brown & Son of Salford. The original pavilion was 50 yards from the entrance and capable of seating 2,500 people. There was a café-lounge, a refreshment room, and shops were on either side of the entrance. The pier and pavilion were lit by electricity and the building was ventilated by a 48-inch electric fan fixed in the dome. The day after the opening ceremony Madame Adeline Patti sang in the pavilion and a streamer with blue and white lettering was hung across the road, which read: 'Welcome To The Queen Of

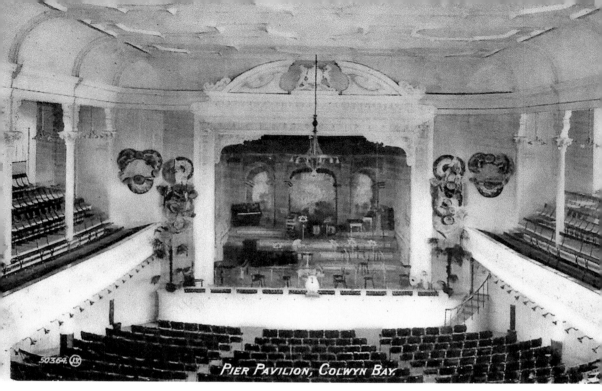

The interior of the first Colwyn Bay Pier Pavilion.

Song'. At the sea end of the pier was the bijou pavilion. The late 1930s and 1940s were the years when hundreds of people would flock to the shows on the pier. The local chimney sweep, Mr Hayton, acted as a sort of barker in the evenings, standing by the main gateway and shouting out the names of the attractions and the costs of the shows. The first pavilion burnt down in 1922, the second in 1933 and the third is now being demolished.

St Paul's Church

The church is the child of Llandrillo-yn-Rhos Parish Church. Lady Erskine gave the land in the middle of the town to the Trustees of Llandrillo Church so that the Church Parochial Council could build a new church in the emerging town of Colwyn. It was designed by John Douglas. It is a large structure, designed in the shape of a crucifix and built with coursed rubble limestone and red stone brought to Colwyn Bay from Runcorn. The nave was consecrated on 13 July 1888 and the chancel on 7 April 1895. The tower was completed in November 1911. The expenditure on the entire church was £12,800. Mr J. Allen JP presented the vicar with the gift of an octagonal pulpit with pierced panels, which he had made himself. In 1920 the eminent architect Mr W. D. Caroe designed the war memorial chapel. The beautiful reredos in limed oadm, stretching the entire length of the east end of the church and costing £1,000, is considered to be Mr Caroe's most successful work. In 1920 Lord Colwyn donated

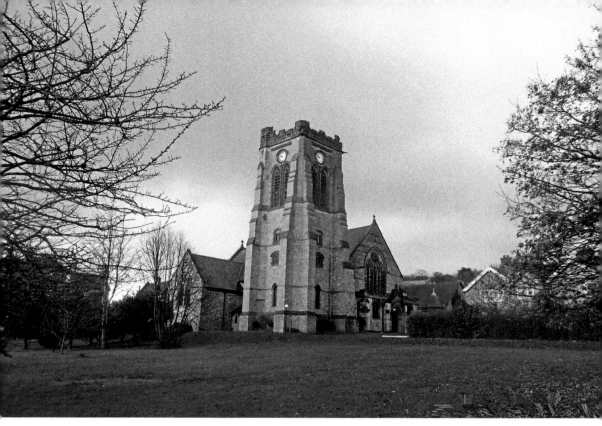

St Paul's Church.

the large west window as a thanks offering for the safe return of his sons from the First World War. In 1938 the bishop of St Asaph wrote, 'The Parish Church of St Paul, Colwyn Bay, is one of the most impressive and attractive of modern ecclesiastical structures.'

Pebi Kilns

One hundred years ago the Coed Coch estate used to quarry limestone from the Llysfaen escarpment, which overlooks Betws-yn-Rhos and Dolwen. They would then fire it in kilns and use the lime to spread over the adjoining fields. In the eighteenth century terrier for Llysfaen there are references to 'Cae Calch' and 'Cae Rodin' – 'Lime Field' and 'Kiln Field'. The evidence of this activity is still there today. The remnants of two kilns lie on the Pebi land in Llysfaen. Pebi probably derives its name from either being near the ovens (or kilns) because it possibly comes from the word *popti*, which means 'oven'. It could also come from the fact that the army used to base themselves on this piece of land years ago and they would have lived in tents; *pebi* (*pebell*) means 'tent' and this could have been tented, *pebyll* land. Woods now encircle the stone kilns that lie in what would have been a small quarry. Large, heavy chunks of limestone were used to build the kilns to such effect that these perfectly cylindrical constructions are

An old Pebi kiln.

still in place today. The inside walls of the kilns were clad in clay, which absorbed the heat. In the 1800s this spot at Pebi would have been a hive of activity: quarrying stone, hauling it across to the kilns, men scurrying about making fires, collecting wood, heaving away the lime. Now the kilns are covered with ivy and sheep graze close by.

The Promenade

The first bit of the promenade to be built was along the coast, from the bottom of Marine Road to the bottom of the Top Promenade, beside the present site of the Coffee Pot café. The second bit was constructed where the pier was eventually built. In 1888 workmen dug out the foundations for the new St Paul's Church in the centre of town. The earth was thrown onto horse-drawn carts and trundled down to the beach, where it was dumped. This rubble formed the bedrock of the promenade, which was built at this site. In 1902 the Colwyn Bay and Colwyn Urban District Act authorised the building of a new promenade and sewage works. The full sweep of the promenade was then built. Norman Tucker described this new promenade as a 'dignified seafront curving with uninterrupted grace for over two-and-a-half miles'. The first section of the promenade to be illuminated was the Rhos-on-Sea section, on 21 June 1905. On a Sunday, after the morning church services, it became fashionable to indulge in a

The glory of Colwyn Bay: its Promenade.

'church parade' along the 'prom'. In 2017 the stretch between the pier and the Coffee Pot was modernised with a new surface, new seating, new railings, new lighting and the inclusion of interesting historical tablets set into the surface of the walkway. The promenade, because of its commanding position and easy availability, has been used over the years for such events as car rallies, May Day galas, town band concerts, May Queen pageants and funfairs.

Public Houses

What is more important to an area and which has the greater impact on a community, the church or the pub? The White Lion and St Elian's Church in Llanelian are side by side. Llandrillo Church used to have a pub, the original Ship Inn, beside the church. The Sun Inn in Old Colwyn was built before St Catherine's Church was built. When Colwyn Bay was in its infancy, The Royal, The Central (now The Station) and St Paul's Church were the three buildings that dominated the town. The Valentine is just across the road from the entrance to St Cynbryd's Church, Llanddulas. Some old pubs, which have now vanished, were built on the route that coaches and horses took in nineteenth century: The Swan and The Eagles in Mochdre; Y Ffor at Four Crosses, where Llanrwst Road and the Old Highway cross each other; Ty Newyddion (The News House) on Tan-y-Wal, Penmaenhead; and Sunnyside on the Old Highway, opposite Uplands Road (still displaying the date '1875'). Mochdre now has the Mountain View;

The Royal.

Rhos-on-Sea has the Cayley, Hickory's and The Fynach, which was once upon a time a monastery; Old Colwyn has The Plough, The Ship and The Marine; The Semaphore is in Llysfaen; and in Colwyn Bay there is the Pen-y-Bryn, The Royal, The Station, Lloyds, Whetherspoon's and The Park.

Pwllycrochan

In the fifteenth century this was one of many houses in the township of Rhiw, but by 1693 it had become a substantial red-brick mansion, built by Robert Conway. In 1700 the property was owned by the Williams family of Rhydygwynt. When Revd Williams' daughter, Jane Silence Williams, married Sir David Erskine of Cambo in Fifeshire they decided to pull down the red-brick mansion and build a white triple-gabled mansion in its place. Sir David was an excellent landlord and improved the estate to the benefit of his tenants. He died in 1841 and his widow with her eldest son, Thomas, demolished part of their home and converted it into an even more splendid edifice, which is still incorporated into the present building on either side of the main entrance hall.

Lady Erskine sold her estate in 1865. It was bought by Sir John Pender who, after a financial crisis in his business laying transatlantic cables, sold the land to a consortium of Manchester businessmen. The mansion was bought from the consortium by Mr John Porter, who opened it as a hotel in June 1866. In 1877 a large east wing and a new dining room were added to the building. For many years it was one of the most successful establishments in the town, attracting a wide variety of visitors. In 1939 officials of the Ministry of Food took over the whole establishment. Lord Woolton, the Minister of Food, liked to have his lunch at Pwllycrochan as he believed the food was better than any he could find in London. When the war ended and the civil servants left the hotel business struggled to survive. In 1953 Rydal School bought the building and it became home to the Preparatory School, where this writer was interned for four years in the 1950s. Seventy-five years later, it is still part of the Rydal Penrhos establishment.

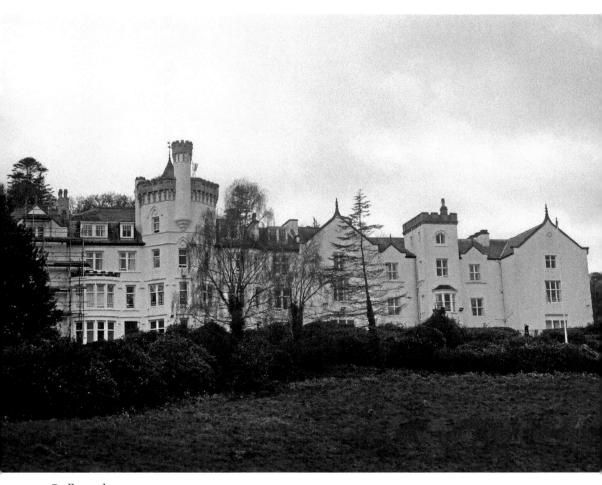

Pwllycrochan.

The Queen's Hotel

This was the premier hotel in the east of the town, situated on the corner of Abergele Road and Queen's Road in Old Colwyn. It was built in 1889 by the local Old Colwyn Builders, Robert Moorcroft Evans and his son David. Queen Victoria's effigy is sculpted in the Ruabon red brick above the doorway. It is a large building and when completed afforded expansive views down to the seashore. There was also a railway station at the bottom of Queen's Road, where the visitors would alight and be taken up the steep hill by pony and trap to the hotel. During the Second World War it was requisitioned by the Ministry of Food. On a huge table in the centre of what had been the dining room before the war, an enormous map of Great Britain was laid on which the civil servants tracked the food that was coming into the various ports around the country. After the war it reverted to its original use. The tourist traffic, however, had more or less vanished and the premises are now used as a nursing home.

The Queen's Hotel.

Queen's Gardens

In 1933 the pier pavilion was burnt down. Four years previously, on 31 December 1929, the council bought from Rydal School, for £7,000, the field in front of the school, running from Lansdown Road to Conwy Road. The following year the field was formally laid out as a municipal garden. After the conflagration on the pier the town councillors considered a bold plan to build a Concert and Floral Hall, at the cost of between £40,000 and £50,000, on the Rydal Municipal Garden. It was proposed by the extravagant councillors to spend £90,000 on entertainment. There were many voices raised against the scheme, chief among them being the minister and members of St John's Church. After much argy-bargy the councillors abandoned their dream and instead spent £15,000 on a new fire-proof pavilion, which is currently being dismantled. During the Second World War the gardens, which some people still called the Rydal Gardens, were transformed into allotments and produced a lot of much needed food for the local residents.

Queen's Gardens.

R

Rembrandt House

This house is on the lower corner of Nant-y-Glyn Road and Nant-y-Glyn Avenue (which is a continuation of Park Road), opposite the side entrance to Nant-y-Glyn Methodist Church. The name is still visible beside the front door. The house became the last home of Robert Banks, a Manchester photographer of the late Victorian and early Edwardian era. He first used the Rembrandt name to promote his business in Manchester in 1874, when he was twenty-eight years old. Subsequently, every house he lived in he named after the painter. He died in 1927, aged eighty-one, and he is buried in Bron-y-Nant Cemetery. For some years after his death, his wife Margaret used the home as a boarding house, earning a small income from it. Mr Banks is commemorated in a book entitled *Manchester: From the Robert Banks Collection*.

Rembrandt House.

Rhos-on-Sea
Methodist Church.

Rhos Methodist Church

This church is one of a string of such churches in Colwyn Bay Circuit; others are Old Colwyn Methodist Church, Nant-y-Glyn Methodist Church and St John's Methodist Church. The first Methodist service in Rhos was taken in 1916 by the superintendent minister, Revd Thomas Nicholson, and was held in the Playhouse, which was then a cinema (unused as such on a Sunday) and is now the Co-op. The foundation stone of the church was laid on the corner of Rhos Road and St George's Road on 14 August 1921. It was attended by a young Indian girl named Monica whom the missionary Miss Tomkinson had rescued from the nefarious clutches of a sinister religious group in her native country. The church was opened for worship in 1923. The first minister was Revd W. E. Sangster, who would go on to be a very nationally influential spirit in the life of the Methodist Church. In 1927, Mrs Sangster became pregnant. Before the birth her husband told his congregation that if the child was a girl, he would hoist a pink flag and if it was a boy, a blue flag. Mrs Sangster delivered twins so he raised the Union Jack. Reverend Ronald Rich, who was the minister from 1955 to 1962, had been in the army during the war and afterwards had started to write comedy scripts with Eric Sykes. In 1984, during the stewardship of Revd Philip Barnett, an extension was added allowing for an enhanced worship area. This church and the Old Colwyn Church are still going strong, but Nant-y-Glyn Church and St John's Church have closed as places of worship.

Rhos Playhouse

In the 1920s Sydney Frere was the top comedian and singer in Will Catlin's troupe of Pierrots. He decided to leave Mr Catlin's employ and branch out on his own. He asked Mr Sydney Colwyn Foulkes, who had already designed the Arcadia Theatre

The Rhos
Playhouse.

on Princes Drive for Mr Catlin, to design a smaller theatre for himself on land he had purchased on Tramway Avenue (now Penrhyn Avenue) in Rhos-on-Sea. The design is straightforward: a long, single-storey stone building decorated with a typically cinematically curved ceiling covered in tricksy plaster rondels and an ornate marble block frontage. In the 1930s there was no breakwater defending Rhos-on-Sea from rough seas and high tides. Seawater would sometimes come rushing down Penrhyn Avenue and Mr Frere's wife, who used to sit in a cubicle in the foyer of the cinema collecting the money and issuing tickets, would sometimes find the seawater would be lapping around her feet. In 1938, Mr Frere sold the cinema to George Lee, a former police officer with the Metropolitan Police. To the joy of courting couples he bought some double seats, which he installed on the back row. He bought them from an old Boeing aeroplane and one day while cleaning them Mr Lee's wife, Carol, discovered a Boeing teaspoon stuffed down under the covers. The building is now used by the Co-op.

Rotary

There are two Rotary clubs in Colwyn Bay. The Colwyn Bay Club began in 1927. Mr A. J. Costain, the headmaster of Rydal School, was its first president. The Rhos-on-Sea Club was created by the Colwyn Bay Club in 1998. The Colwyn Bay Club meet in the Colwyn Bay Cricket Club restaurant and the Rhos Club meet in the Rhos Fynach Restaurant. Over the years members of both clubs have raised an enormous amount of money, which has been distributed among people and institutions in the town. Geoffrey Edwards (president of the Colwyn Bay Club in 1976) was the town clerk, Revd Hugh Rees (president in 1959) was the canon of St Paul's Church, Donald Hughes (president in 1955) was the headmaster of

Rhos Rotary Club's Christmas Tree of Lights.

Rydal School, Edgar Poppleton (president in 1983) ran his own very successful heating and ventilating business, Bill Flint (president in 1977) was the borough librarian, and both Mr W. S. Wood (1931) and Edward Allen (1930) owned the two most prestigious shops in the town. The Rhos Club has now raised nearly £200,000 for St David's Hospice through their Christmas Tree of Lights. The moto of the Rotary movement is 'Service Above Self' and one of the four creeds that the members follow is the 'application of the ideal of service in each Rotarian's personal, business, and community life'. The members of the town's two clubs have consistently exemplified those ideals.

Rushmere

Rushmere is the name of the house at No. 32 Allanson Road. Mr William Wood arrived in Colwyn Bay in 1911 and opened his store, W. S. Wood, in Station Road. This became one of the most successful and prestigious businesses in the north-west of the country. He was born and had done his courting in the hamlet of Rushmere, around

Mr Wood's former home.

5 miles south of Lowestoft, Suffolk. The hamlet has a manor farm, a tiny Norman church and a row of terraced cottages. Thus in a salute to the village of his birth, he named his new home on Allanson Road. The name is still on the gatepost.

Rydal School

This school on the corner of Pwllycrochan Avenue and Lansdown Road started life in 1885 when Thomas Osborn was persuaded to become the first headmaster. He arrived in Colwyn Bay with his wife and his seven children. It was originally called Rydal Mount and on the first day there were fifteen boys in the school. The school building had been the home of Revd Frederick Payne, a wealthy man. He generously gave the building to the new school and moved up the road to Beechhome. One hundred and thirty-three years later and the school is thriving, having joined forces with Penrhos College. It is now known as Rydal Penrhos.

Mr Osborn's successor, Revd A. J. Costain, was an inspirational headmaster and the number of pupils rose steadily during his stewardship, even during the war years when the school was moved to Oakwood Park in the Sychnant Pass to make way for the arrival of the Ministry of Food.

Today, the school possibly has a larger building stock than any other organisation in the town. The school owns eight extremely large houses, all built originally as family homes, which all only provided shelter for the first family occupants before they were purchased by Rydal: Walshaw and The Grange on Oak Drive, Hathaway on Lansdown Road, Beechhome and Outram Lodge on Pwllycrochan Avenue, Heathfield on Queen's Road, Ingleside and Netherton on Brackley Avenue, as well as Pwllycrochan itself and the main building, which has taken up an ever-expanding area from Pwllycrochan Avenue to Queens Road.

Originally, it was a boarding school for boys; however, today there are many female students and many day pupils. The school now also admits pupils from around the world.

The Grange.

S

The Seashore

Had the Victorians not constructed the promenade, the sea would now be lapping at the bottom of Station Road. There is a photograph taken in the 1880s showing a fringe of turf between the embankments and the shingle. This was the last remnants of the Morfa, which has now disappeared. In 2013, thousands of tons of sand were dumped on the beach to regenerate the shore and entice visitors onto the beach. In the 1920s wooden groins were built on the beach at right angles to the promenade to break up the heavy waves, and in 2012 enormous rocks were placed abutting the sea wall to protect

The Rhos-on-Sea breakwater.

the wall from damage. In the 1980s a massive rock breakwater was constructed on the shore at Rhos-on-Sea to stop the unforgiving waves from crashing onto the promenade. The seashore, which extends with its unfettered curve of sand from Rhos-on-Sea to Old Colwyn, is a popular attraction for families and bathers in summer.

The Seventy Degrees Hotel

This hotel, built in 1972 and prominently perched on the lip of Penmaenhead, has now been demolished and is being replaced by a mixture of flats and houses. The builder was Gwynedd Caradog Jones and the architect was Stewart Powell Bowen; he employed a man called Leonard Fionette who was known to his young son, Paul, as Mr Fishnet. Mr Jones owned the land beside the lay-by at Penmaenhead and had intended to build a small wayside café. Mr Bowen, however, persuaded him to apply for a grant and build something far grander, which he argued the site demanded. Mr Bowen estimated the cost of building the hotel to be around £110,000, an estimate that proved to be highly inaccurate. The Seventy Degrees Hotel was so named because of the angles used in its construction. It made for an unusual concept, but from the builders' point of view, proved a terrible waste of material. The whole building was based on a steel frame erected on rock, the drilling of which took longer than expected. The hotel became a popular venue for evening functions for many local societies and clubs and for wedding receptions.

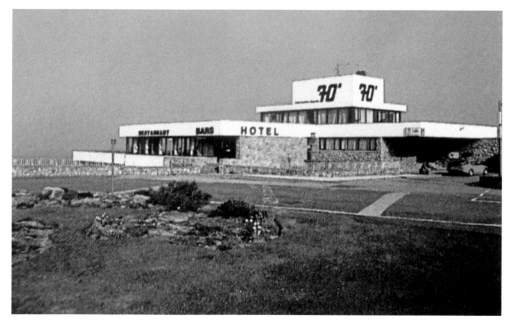

The Seventy Degrees Hotel.

T

Tan-y-Bryn Road

This road traces the line of a medieval track running from Conwy Road to Llandudno Road and was once an important thoroughfare in the area. It was probably used before this by the Romans as Roman coins have been found close by, as has a well-preserved first-century amphora and a storage jar used to transport wine and olive oil was found in the back garden of a local house.

In 1819, Llandrillo parishioners provided a school at a cost of nearly £400, which was built beside the road. The pupils – boys and girls – were very poor, many of whom could not afford the 1*d* a month fee. The school was eventually pulled down as its usefulness had been dissipated by the creation of the board school in 1876, and Tan-y-Bryn Hotel was built on the same spot. Towards the end of the nineteenth century five very prestigious large manor houses were built on the western side, on the slopes of Bryn

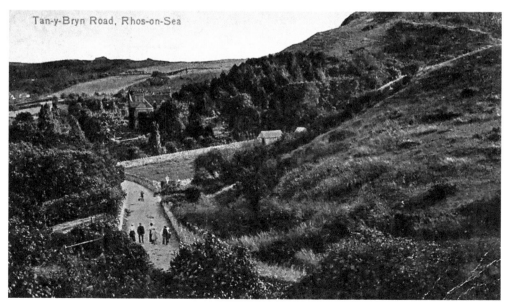

Tan-y-Bryn Road, *c.* 1920.

Euryn. Tan-y-Bryn later became a hotel and has since been demolished to make way for the erection of four large houses: Bod Euryn, which eventually became a nursing home; Rockwood, which was pulled down and replaced by a Methodist nursing home called Coed Craig, the Welsh for 'Rockwood'; Plas Euryn, which over the years has been transformed into the Plas-y-Bryn nursing home; and Plas Dinarth, which was the home of the local solicitor and landowner William Horton, and has since been demolished to make way for the Horton Drive estate.

Telegraph Station

This station stands on the summit of Mynydd Marian, a hill that dominates the village of Llysfaen. From 1826 to 1853 the Telegraph Station, which is in fact built like a house, was part of a chain of signalling stations sending semaphore messages

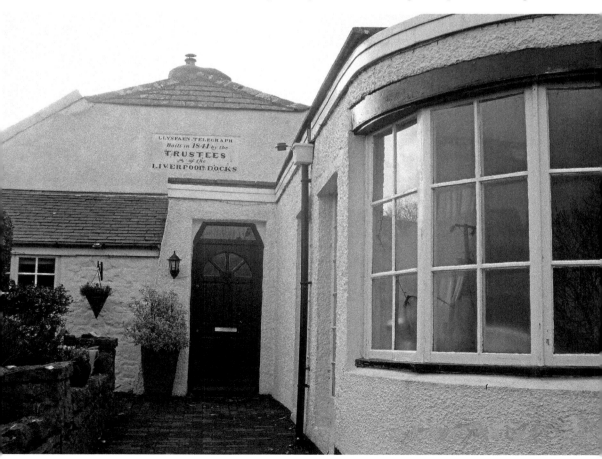

Telegraph Station.

from Holyhead to Liverpool. Shortly after a boat docked at Holyead, the merchants of Liverpool and the owners of the vessel would have known about its arrival. Before the Telegraph Station was built a beacon would have been lit on the summit of the hill, which would have been a beacon in a chain of beacons, among which would have been one on the Great Orme and one on Bryn Euryn warning the local people of North Wales that an enemy was approaching.

At this spot in the Stone Age people hunted for game and gathered wild plants. Now the area surrounding the Station is a nature reserve and the only animals are the dogs pulling their owners along for their daily constitution. For many centuries the people of Llysfaen grazed their livestock on Mynydd Marian but the practice petered out in the 1960s. Two years after the Telegraph Station closed a local lady named Mary Price died. She is buried beneath a slender tapering stone pyramid in St Elian's Churchyard, which is inscribed: 'Mary Price, widow of the late Rev James Price Rector of Llanfechan died Sept.15 1855 aged 87. Near this spot lies a little grandson who died on board the Rhyl Packet. There is hope of Old and Young, hope for Thee too reader only from the finished work of Jesus.' A poignant reminder that while we may pass away, Mynydd Marian remains forever.

Theatre Colwyn

This 329-seat theatre was built towards the end of Queen Victoria's reign. It was originally known as The Public Hall (as the inscribed name above the entrance testifies) and is the only venue left in the town in which a live show can be staged. It is mainly used today as a cinema. The first film screened in the Theatre was in 1909 when the building was run by the ubiquitous entrepreneur Harry Reynolds. It is believed to be the United Kingdom's oldest operating cinema. In 1930 a huge fire tore through the building, causing the roof to collapse in onto the stage. The Theatre lay empty for six years and when it reopened the first performance was 'The Yeoman Of The Guard', performed by the Colwyn Bay Operatic Players. Terry Jones, of *Monty Python* fame, is a patron of the Theatre as is the actor and writer Celyn Jones. Over the years the Theatre has been home to the Abbey Players, who staged a well-received annual play. A regular cast member, Pam, could be seen in Colwyn Bay, piled high with bulging carrier bags, wandering the streets and being pulled along by a small wiry dog on a long lead. Pam was a small lady with a deep, gruff voice and was not blessed with good looks. In one play she shot across the stage like an arrow, heading for the leading male actor to plant a smacker of a kiss on his defenceless lips. You could feel the entire audience recoil in horror at the spectacle as it unfolded before their eyes.

THE

Prince of Wales
THEATRE

The end of a Perfect Day..!

★ **Professional Summer Show**

★ **Drama Festival** ★ **Variety Concerts**

★ **Wales in Song Sunday Concerts**

Abergele Road, Colwyn Bay *Box Office: Tel 2668*

48

Theatre Colwyn, *c.* 1979.

Three Severed Heads

Ednyfed Fychan, who lived from 1170 to 1246 and resided at Llys Euryn on the slope of Bryn Euryn, was a descendent of the Lord of Rhos and an ancestor of Owen Tudor, and thereby of the Tudor dynasty. He was a Welsh warrior and the chief counsellor of the Gwynedd prince Llewelyn the Great. The three severed heads are depicted on his coat of arms. It is said that Ednyfed killed three of the chief captains of Ranulf, Earl of Chester, in battle and as a result he was ordered to replace the severed heads of Saracens on his coat of arms with those of three Englishmen. It would appear that the head as a symbol is much older than the thirteenth century. To the Celts the human head was venerated above all else. To them the soul, the centre of emotion as well as life itself, a symbol of divinity, and the power of the otherworld were all in the head.

Ednyfed Fychan's coat of arms.

Trams

The tramline originally ran from the Queen's Hotel in Old Colwyn through Colwyn Bay, Rhos-on-Sea, Penrhyn Bay and Llandudno, ending up at the West Shore. The first attempt, in 1897, to obtain permission to build a tram track was rejected on the grounds that the local landowners had not been sufficiently considered. Permission was eventually secured on 2 June 1899. The engineers for the project were Messrs Hewitt & Rhodes, who worked to a budget of £99,440. In 1907 the first part of the line from Rhos-on-Sea to the West Shore was opened without ceremony, except for cheers and bell-ringing from the spectators. The depot was on Penrhyn Avenue, a site that a housing estate now occupies. The tracks through Colwyn Bay were finally laid in the summer of 1908.

In the summer local people used to love to travel on the 'toast-racks', which were single-decker open-topped trams. The ticket collector used to swing along the outside of these trams, collecting the money and handing out the tickets while at the same time hanging on for dear life as the tram trundled along through the town. After the Second World War it was inevitable that the tram service would come to an end: the company did not have the finances to repair the line and there was too much competition from the new bus service. The last tram ran late in the evening on Saturday 24 March 1956. Pennies were laid on the rails as a symbolic last offering.

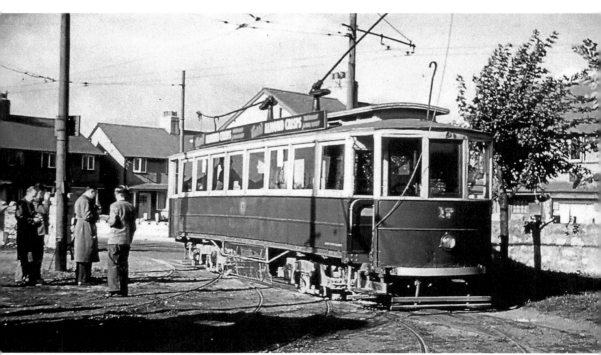

Tram at tram shed on Penrhyn Avenue, *c.* 1952.

United Reformed Church

This church (originally a Congregational Church) on the corner of Abbey Road and Colwyn Avenue is a fine example of the Arts and Crafts architecture. The first part to be built was the church hall and classrooms on the corner of Penrhyn Avenue and Colwyn Avenue at a cost of £1,600 in 1910. This building is now being demolished.

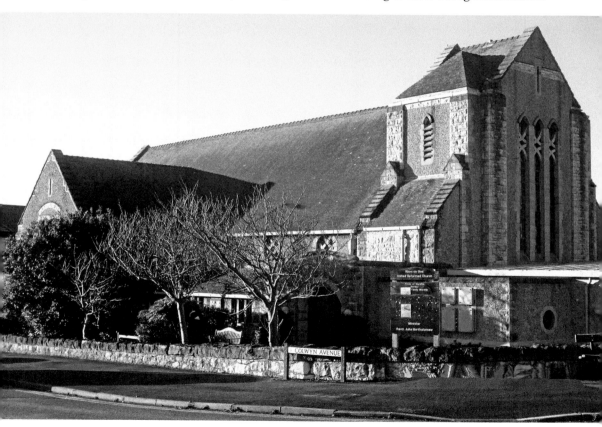

The Rhos-on-Sea United Reformed Church.

At the first committee meeting it was agreed to 'get a bucket and mop and mantles'. Because the council needed the land beside the church hall in order to widen the road, in 1919 the deacons decided to buy a plot of land at the other end of Colwyn Avenue as the site for the new church. The building of the church began in 1929. Bradshaw, Gass & Hope of Bolton were the architects and the builders were Bithell of Llandudno Junction, who included moulded mullions and circular clerestory windows with tracery of intersecting curves and diagonals in the design. The trustees declared that it was the 'desire of the committee to erect a dignified building expressive of the purpose for which it is to be used'. In this resolve they were successful. The trustees allowed the expenditure of £33 for 'bushes, trees and plants for the church grounds' and the records reveal that the head gardener at Bodnant, Mr Puddle, gave valuable advice on the effect of wind and sea spray on the windy corner. During the Second World War a canteen was opened at the church and 70,000 cups of tea were served between September 1939 and December 1940.

Upper Colwyn Bay

This area of the town used to be a distinct village in its own right, in the countryside above the Colwyn Bay town. It was divided from the town by the Pwllycrochan Woods on one side and the village of Bryn-y-Maen further to the east. There was a string of cottage homes along Llanrwst Road and one or two on Cherry Tree Lane, Honeysuckle Lane and Copthorn Road. The posh houses on the lane leading to The View were built at a later date. It was a Welsh-speaking community who attended Sion Chapel on a Sunday. During the Second World War, Mrs Woodyear, who lived on the corner of Llanrwst Road and Honeysuckle Lane, was an excellent source of black market eggs. The once-a-day bus service would be used to deliver fish and turkeys at Christmas and the Colwyn Bay ironmongers, G. Bevan & Co., were sometimes prevailed upon to use their works van to deliver hot cross buns at Easter time – the smell of paraffin on them didn't seem to worry the small Upper Colwyn Bay community one jot. The toffs from the town only ventured up to this other world to play golf. It was a course (now covered with houses) that catered exclusively for the solicitors, bank managers, doctors and business men of the town – there were no female players. In the days before the Second World War, when no one in Upper Colwyn Bay possessed a car, most of the residents' food was bought from the surrounding farms. Today it is a busy area with its own school, pub, shop and regular bus service. Hot cross buns don't smell of paraffin any longer.

Sion Chapel.

Reverend Venables-Williams

Reverend Venables-Williams was the vicar of Llandrillo-yn-Rhos Parish Church for thirty-one years (1869–1900), during which time he arranged for the construction of the underpass underneath the railway line beside the station (from the Colwyn Bay town to the promenade) along with the road from Rhos-on-Sea to Penrhyn Bay beside the present golf course. Both of these ventures came to be known as the 'vicar's roads'. On the promenade in Rhos-on-Sea there is a stone drinking fountain, constructed in 1906 to commemorate his service to the local community. As the chairman of the Colwyn Bay Urban District Council he was able to secure a substantial reduction in the price of education for the poor of the parish and he argued that the railway company should be fully rated, thus securing a reduction in local taxes. He was instrumental in creating both the parish of Colwyn Bay and Old Colwyn out of his own all-encompassing Llandrillo parish. He was somewhat miffed when the ecclesiastical powers that be decided that he could not be the vicar of both Llandrillo and Colwyn Bay, a position that he had assumed would be his. His tenure as a magistrate was not seen as a great success by the local solicitors, as he showed considerable bias towards local landowners and the hierarchy of the town and much prejudice against the lower orders – justice was not his forte. This stubborn streak manifested itself in the heavy-handed way in which he dealt with the imposition of the tithes or taxes that were due from the farmers to Llandrillo Church. He demanded that they be paid. The farmworkers rioted against his decision, which was overturned, with the result that the tithes were eventually abolished. However, he was strongly in favour of the disestablishment of the Anglican Church in Wales and also held tolerant and broad religious views, often supporting events arranged to raise funds for the various chapels in the area.

Revd Venables-Williams' grave.

M. Henri Verbrugghen

When the Colwyn Bay Pier was opened on 1 June 1900, M. Henri Verbrugghen, who was considered at the time to be one of the finest living violinists, was appointed as the deputy conductor of the Pier Orchestra. He and the musical director, M. Jules Riviere, conducted the orchestra in front of an audience of 3,000 people – the trustees of the pier had pinched both men from Llandudno Pier orchestra.

Verbrugghen had been born in Brussels in 1873 and made his first appearance as a violinist when only eight years old, at the Brussels Conservatorium. Nineteen years later he was in Colwyn Bay, where he stayed for four years. He moved to Australia and then on to America, where he played in the Minneapolis Symphony Orchestra. He died in 1934 in America. He was a vastly talented musician and the trustees of Colwyn Bay pier had been fortunate to hang on to him for four years.

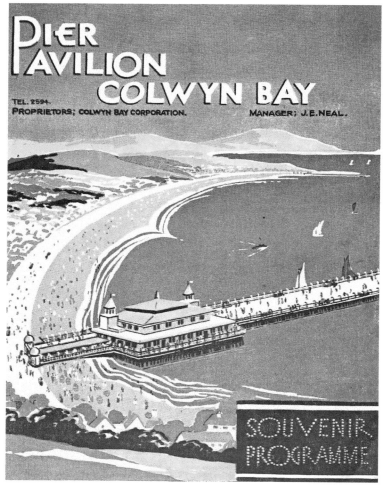

Mr Verbrugghen's place of work.

Queen Victoria

It was during this queen's reign (1837–1901) that the town expanded greatly in building and enterprise. In 1887, the whole town went to the Flagstaff (where the zoo is now located) for a picnic in honour of the queen's jubilee. The Victoria Jubilee Cottage Hospital was opened in 1899 and the first pile in connection with the erection of the Victoria Pier was driven into the sand on 1 June that same year. The Queen's Hotel in Old Colwyn was also built, complete with Victoria's effigy chiselled out in the stonework above the doorway; The Royal, an alehouse on the corner of Abergele Road and Sea View Road, was built in 1875; Mr Porter built his house named Braeside on Pwllycrochan Avenue in 1891; the Metropole Hotel (now Housing Association flats) on the corner of Penrhyn Road and Princes Drive was opened in 1899; both St Paul's Church and St John's Church were built in 1888; Rydal Mount School was opened in 1885, and Pen-y-Bryn Junior School was opened the following year; William Owen built and opened his new fish shop on the corner of Station Road and Abergele Road in 1899 (the date is on the façade); the Oaklands on Conwy Road (now home to Amphlett's, the solicitors) was built in 1877, as the date on the front of the building testifies; the railway station was opened and the line laid in 1859; out of the lovely stone cottages built by Whitehall Dodd on Rhos Road, Nos 60–66 were built in 1857 and 1883; and Queen's Drive and Victoria Park are, of course, named in the queen's honour. The self-confidence and the hardworking ethic of the Victorian era was a boon to the fortunes of Colwyn Bay.

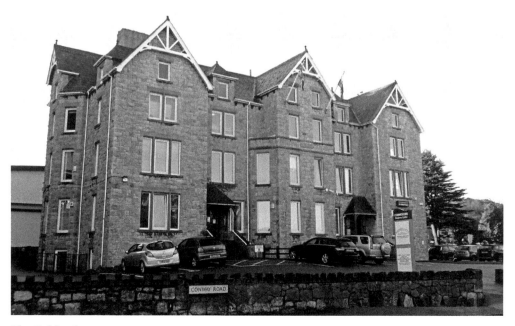

The Oaklands.

War Memorial

The Colwyn Bay war memorial used to be outside the original Town Hall, on the corner of Rhiw Road and Conwy Road. It is now in Queen's Gardens. In March 1922 the chairman (Simon Williams), treasurer (D. Gamble) and secretary (T. R. Roberts) of the War Memorial Committee issued a circular inviting subscriptions for the erection of a town memorial to 'commemorate the glorious sacrifice' made by local men in the First World War. They needed £1,000, and they got it. The Right Honourable Lord

The war memorial.

Colwyn unveiled the memorial on Remembrance Day – 11 November – in 1922. It was sculpted by Mr John Cassidy of Manchester and the bronze founders were H. H. Martyn & Co. Ltd of Cheltenham. Of all the names on the panels surrounding the base of the memorial, there is the name of one woman: Staff Nurse Catherine Williams QAIMNS. The memorial in Old Colwyn was also built by public subscription on land belonging to St Catherine's Church and was unveiled by Miss Broderick of Coed Coch on Aristice Day 1923.

The White Lion

This is the Llanelian public house. In 1699 Edward Lhwyd wrote that, 'There are by ye church but four of five houses'. The community has grown since then but it still retains its ancient village proportions and feel. A white lion was the symbol and crest of the Holland family of Teyrdan, the local landowners. Squire Humphrey Holland, as his gravestone notes, was buried in the adjacent church cemetery in 1612. Some bits of the present building date back to the fourteenth and fifteenth centuries. The church next to the pub, where the Squire is interred, dates back to AD 540. Ancient records explain that after the parish meeting in the church in AD 722, the elders retired to the alehouse close by for their free monthly jug of ale.

The White Lion.

Woods' Department Store

Peacocks department store now own this building on Station Road. The original business and the present building were the brainchild of the entrepreneur William Stead Wood. He began his store, which mostly sold ladies' clothing, from the original two buildings on the east side of the road that occupied the site. The buildings on the east side were built to their owners' differing requirements and are as such all different; whereas those on the opposite side of the road were conceived and designed by Booth, Chadwick & Porter as one long, similar conception – from the Imperial Hotel to the Central pub. Mr Wood wanted a new purpose-built shop with an arcade at the front and asked his good friend Mr Sydney Colwyn Foulkes to design such a structure for him. Thus the lovely Romanesque building we see today was designed, which was opened with much ceremony in 1933. Above the shopfront are two art deco busts on pedestals, a typical Colwyn Foulkes touch. Concern was expressed by the owners of the two properties that stood on either side of Mr Wood's original property. They wondered whether theirs would collapse when Mr Wood's shops were demolished. They were assured this would not happen, which was correct; it came as a great relief to both Mr Wood and Mr Colwyn Foulkes. The front of the building is clad in Portland stone, an idea suggested by Mr Peake, who ran the firm making the high-quality Rodex coats, an item that Mr Wood sold in his store. Mr Wood's daughter married Derek Armitage, a well-known and highly respected local solicitor.

Woods' Department Store.

X

X-rated

Colwyn Bay has had a rather sedate history, but now and again the town has been able to show that it is not exactly a backwater town either. During the Second World War when the Ministry of Food descended on the town, it was discovered by those who went searching for such things that there was another arrival from London, 'Picadilly Lil' – a prostitute. She must have been an enterprising young lady to see the financial opportunity offered by the arrival in the town of 5,000 civil servants from our capital city. Ironically, she felt safer in Colwyn Bay working as a prostitute than she would have done in London, where it was raining bombs. It was reported by Norman Longmate in his book *How We Lived Then* that she lived in a 'nice group of houses', so she was doing OK.

For around four months in the 1990s, a bevy of prostitutes were ensconced in one of the most historically important buildings in the town before the local magistrates

'The ladies' waved their encouragement from here.

were able to decree that they should be shifted on. Young local boys took enormous delight in waving vigorously up at the second-floor windows of the Station Road building (which had, once upon a time, been the home of the local council, a local bank and the police station) and the 'ladies of the night' enjoyed, among much laughter, waving back at them.

In 1973, a right rumpus was caused by the projected screening of *The Last Tango in Paris*, a very naughty film starring Marlon Brando. The canon of St Paul's Church, Revd Hugh Rees, who had not seen the film, was pitted against local film buff and window cleaner Mr Reckless, who was desperate to see it. After a private screening for local councillors and magistrates, who decided that they had not left the cinema having changed into depraved monsters, the film was passed for viewing by the lesser mortals of the town, which made one window cleaner very happy.

X-ray

In its day the X-ray department of the Colwyn Bay Cottage Hospital was the most up-to-date facility in the North West. The new equipment was installed in 1929. In the coming years there was a bevy of eminent surgeons who started their careers in Colwyn Bay Hospital, prominent among them was Professor Robert Owen, who would travel the world practicing and lecturing as an orthopaedic consultant surgeon. Mr Peirce Williams was the consultant anaesthetist and Dr Herbert Lord would eventually become a surgeon and the doctor in charge of all the pupils at Rydal School.

Directly opposite the hospital at Ty Gwyn, Mr Frank Booth MRCVS ran his veterinary practice. One day a local farmer from Llanelian brought his pig to Mr Booth's surgery. The pig was in some distress and the farmer could not work out why and after a thorough examination Mr Booth could not discover the reason for the pig's lethargy either. He had the brilliant wheeze of dragging the poor porker across the road to the glistening X-ray department of the hospital. Amazingly, and a lovely indication of the times in which they lived, the vet, farmer and doctors all helped to yank the pig onto the table, where it contentedly squealed while its innards were photographed – all courtesy of the National Health Service.

Frank Booth's
veterinary surgery.

Y

Yerburgh Avenue

The avenue is named after Elma Amy Yerburgh. She was the daughter of Daniel Thwaites, who owned the family brewing business and was thus born (in 1864) into great wealth. In 1888 she married Robert Yerburgh, who was the MP for Chester. On the death of her father, although his will made provision for the brewery business to be sold and for all the proceeds to be held in trust for his daughter, she decided to retain ownership of the enterprise and allow the executor of her father's will, William Ward, to run the business. After Mr Ward's death Mrs Yerburgh transferred the business into a limited company, and with the additional funds Daniel Thwaites & Co. Ltd went from strength to strength. Her husband died in 1916 but she continued to take a full interest in the running of the business. She was a kind, benevolent employer who took a keen interest in the welfare of her staff. In 1897, she began a tradition of giving a Christmas gift of 10 lb of English beef to every workman and a turkey to the office staff. In 1926, her managers wanted to stop this generous handout, but she insisted that it continue on the proviso that £1 be given to everyone instead of the food. This thoughtful gesture became known as 'Elma's Pound'. One of her many homes was Bryn Eithin and its 'out house' Cae Eithin, on Llanrwst Road. This is now a nursing home. The road off Victoria Park, across Llanrwst Road from Bryn Eithin, is Yerburgh Avenue, which she insisted should be named after herself.

Bryn Eithin.

Zoo

Colwyn Bay Zoo is the exclusive creation of the late Robert Jackson. Some years ago Mr Jackson's wife Margaret received a letter addressed to the 'creator' of the zoo. Mr Jackson was born in Knutsford and from an early age, like Gerald Durrell, a friend of his, took a keen interest in animals. In 1958, he set up a company with George Cansdale called Zoological Exhibitions Ltd, and four years later he and his family moved onto the Flagstaff estate with the help of the local Colwyn Borough Council, where he opened his zoo on 18 May 1963. Mr Jackson died suddenly while he fishing in the Clwydian Valley when he was struck by lightning. Nick, one of Mr Jackson's sons, is still very much involved in the running of the zoo, which is now of national importance and attracts many thousands of visitors every year. In the early 1930s the estate was the home of Dr Walter Whitehead, a surgeon from Manchester. Mr Whitehead had employed Thomas Hayton Mawson, the most celebrated landscape architect of the Edwardian era, to landscape and plant the estate. This work came to a stop when Dr Whitehead ran out of money, but bits of Mr Mawson's work can still be seen as you amble around the zoo.

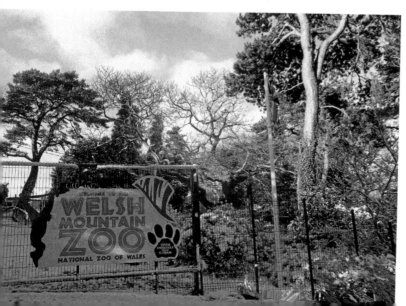

Entrance to the zoo.